NOV 1 6 2004

The Painter's Corner

HEADS AND PORTRAITS

BARRON'S

HEADS AND PORTRAITS

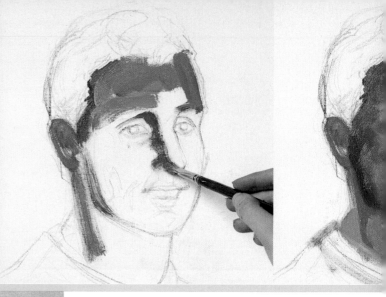

©Copyright 2003 of English translation by Barron's Educational Series, Inc., for the United States, its territories and possessions, and Canada.

Original title of the book in Spanish: *Cabeza y Retrato*
©Parramón Ediciones, S.A., 2001
Published by Parramón Ediciones, S.A., Barcelona, Spain

Translated from the Spanish by Michael Brunelle and Beatriz Cortabarria

Authors: Parramón's Editorial Team
Editor in Chief: Mª Fernanda Canal
Editor: Tomàs Ubach
Photography: Nos & Soto
Text and Coordination: David Sanmiguel
Projects: Miriam Ferrón, Mércedes Gaspar, Josep Torres, and Yvan Viñals
Design: Josep Guasch

All inquiries should be addressed to:
Barron's Educational Series, Inc.
250 Wireless Boulevard
Hauppauge, New York 11788
www.barronseduc.com

International Standard Book No. 0-7641-5605-5

Library of Congress Catalog Card No.: 2002116911

Acknowledgments
Parramón Ediciones, S.A., wishes to express their gratitude to Adriana Berón, Mercedes Castro, Sergi Oriola, Alejandra Ravassa, and Antonio Restrepo for their kind collaboration on this book.

Printed in Spain
9 8 7 6 5 4 3 2 1

Contents

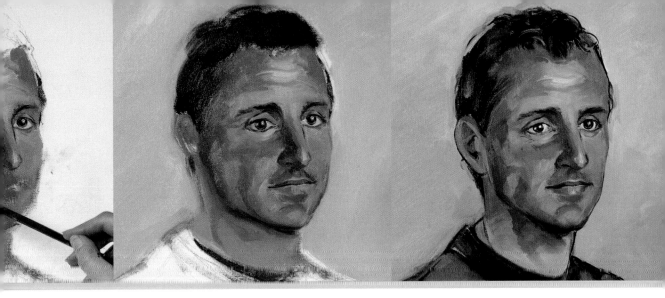

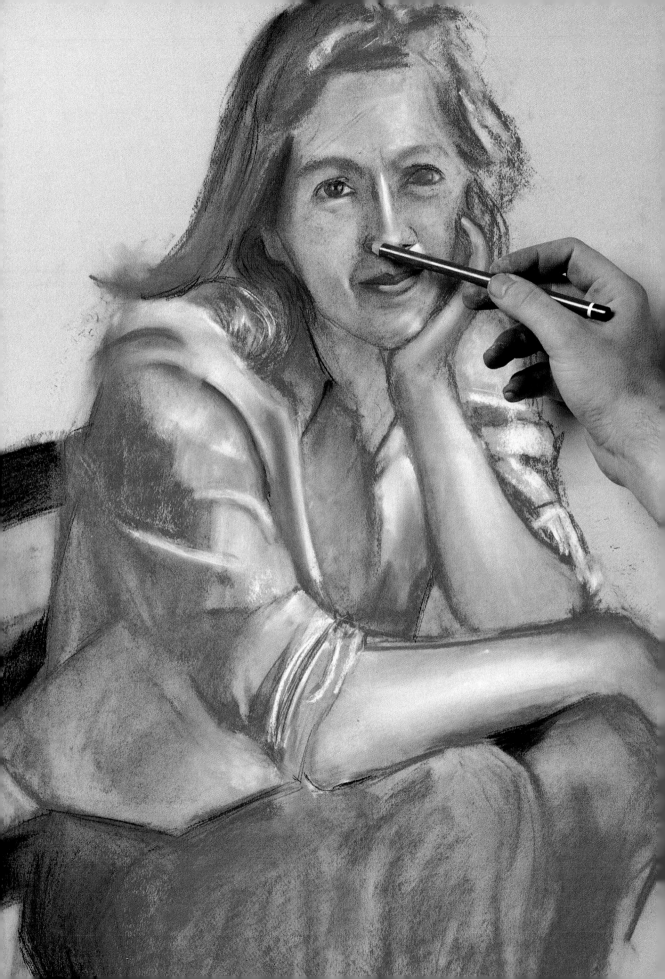

Introduction

The art of portrait making is one of the most sophisticated and engaging genres for the artist. It is a genre that requires previous experience in drawing and painting and a somewhat daring attitude because the person represented in the portrait is also the most demanding critic of the work. This is also a genre full of possibilities, which forms part of the most human aspect of painting: the representation of a particular man or woman, the expression of a personality on a piece of canvas or paper. Portrait making presents passionate challenges, which are at the same time very delicate: the idiosyncrasies of the person represented, the difficulties of achieving a resemblance, the conflict between the style of the artist and the expectations of the person who is posing for the artist, and so on.

The purpose of this book is to present a detailed review of all the technical aspects of portrait making. They range from the basic decisions regarding the composition (portrait of a bust, half body, full body, and so on) to finding clues that make the creation of a good resemblance possible, to the study of the most appropriate pose for each type of portrait and the placement of the painter before the model.

The entire contents of this book are appropriately illustrated to make understanding them easier and to guarantee that the reader learns this genre, which is above fads and styles and has always enjoyed great popularity.

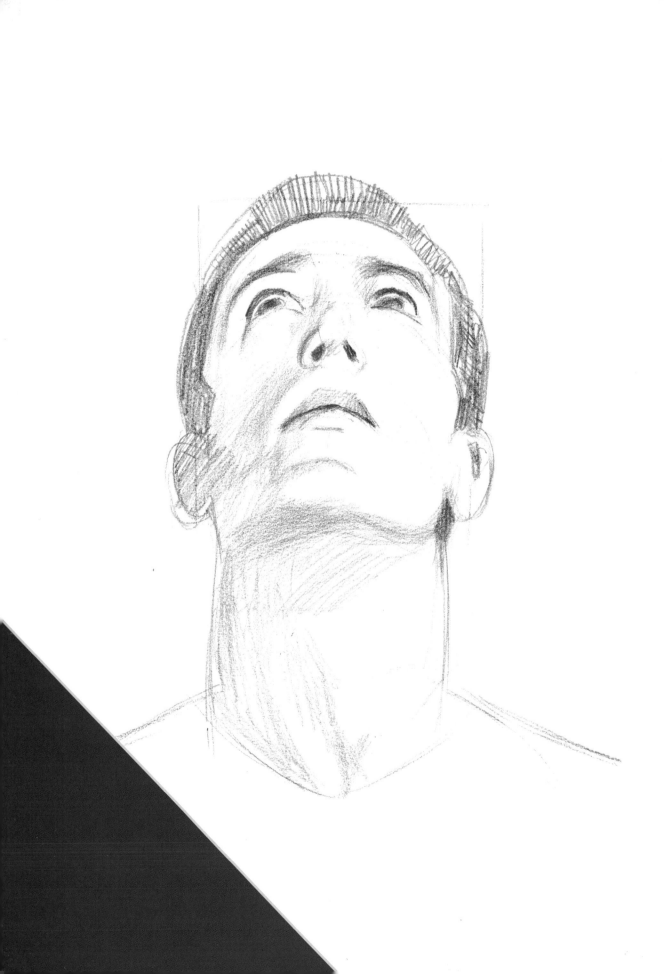

Portrait Making in Art History

Portrait making is an artistic method that reflects a natural curiosity toward our fellow humans. History is full of examples in which the personality of the subject is represented with dignity thanks to the artistic talent of the painter.

Of all the artistic genres, portrait making is the one that has changed the least throughout history. There are truly very many differences between a portrait from the Renaissance and a modern one. However, most of them are incidental and depict the fashion tendencies of the time, like clothing, hairstyles, and furniture. The face and expression, though, do not change. It is as easy to recognize the deep psychological and moral significance of a face from ancient Rome as it is of one from the nineteenth century. The social circumstances that always surround human life are inevitably reflected. The courtly, bourgeois, and urban or rural atmosphere make the portraits of different artistic times easy to recognize. The decorative style of each historical moment informs us of the world each person lived in. However, what the modern viewer is most impressed with is the way in which the great portrait artists of the past represented the essence of a temperament exclusively through artistic means, creating compositions and combinations of such expressive forms and colors that they elevated and conferred the highest dignity to ordinary people.

♦

It is as easy to recognize the psychological and moral significance of a face from ancient Rome as it is of one from modern times.

♦

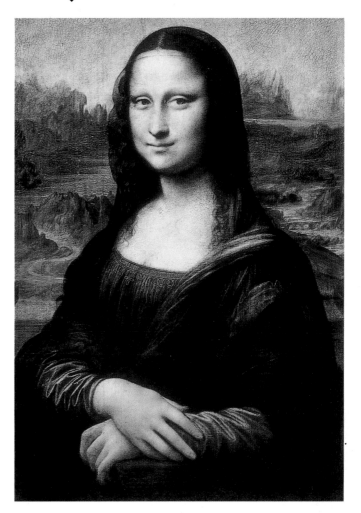

Leonardo da Vinci, The Mona Lisa. *Louvre Museum (Paris, France). In many ways, this work symbolizes the art of portrait making in its entirety. All the aesthetic and psychological virtues associated with the genre are contained in this great work of art.*

The First Western Portraits

Very few artistic examples from ancient Greece and Rome have survived to this day. Therefore, it is very difficult to know for sure how popular portrait making was. The few examples preserved from that era suggest that portrait making was common and that portraits revolved around commemorative themes. Of the few examples that can be cited, the portraits that include the mural decorations of Pompeii and, above all, the funerary tablets from El Fayum in northern Egypt are the most relevant. In both cases, the artistic quality is very good and the realistic achievement is as intense as any of the faces of the Renaissance. All these paintings are done with tempera or encaustic—a very durable technique that consists of applying colors with melted wax—either on murals or on canvas.

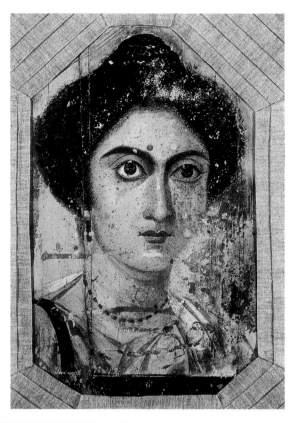

Woman's portrait from El Fayum. Archaeological Museum (Florence, Italy). This is one of the famous Egyptian portraits of the Roman era. These works look surprisingly modern, and this one displays a very profound naturalism due to the strong facial expression.

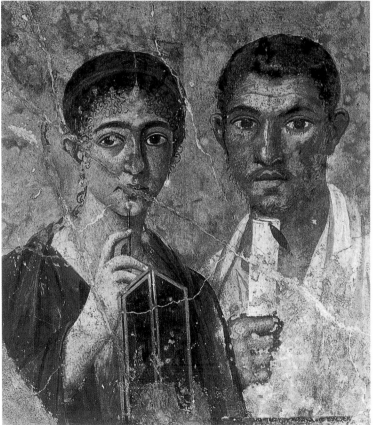

The Portraits of El Fayum

The greatest examples of ancient portraiture can be attributed to the funerary body of work of El Fayum. It consists of small wood plaques that were placed on wooden sarcophagi depicting the face of the deceased and were created between the third and fourth centuries A.D. They are incredibly realistic, displaying a powerful facial expression. Many of these portraits reveal the hands of great painters, whose technique and ability to capture the resemblance of the person make them the first great portrait painters in the world.

Portrait of Paquio Proculo and his wife. National Archaeological Museum (Naples, Italy). This work comes from the decorative mural of a house. Its decorative quality did not prevent the artist from pursuing the accuracy of the resemblances and the significant facial expressions.

Portraits from the Renaissance

During the Middle Ages, portraits were nothing more than a series of conventional features repeated over and over again. The portrait, as understood today, did not make its appearance until the rise of the bourgeoisie as a political and social power. During the fifteenth century, the wealthy European families commissioned religious works and requested to have their portraits represented in a corner of the painting, portraying themselves adoring the Virgin Mary or the saint depicted in the composition. The figures portrayed in this way were known as donors because the work was usually associated with a donation to the church.

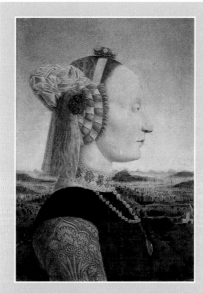

Piero della Francesca, Batista Sforza. *Galleria degli Uffizi (Florence, Italy).*

PROFILES OF THE RENAISSANCE
During the fifteenth century in Italy (especially in Florence and Sienna), profile portraits became popular. They stemmed from the medallions and coins minted in ancient Rome. Their goal was to confer dignity and emblematic power to painting. These portraits consisted of busts whose profiles were outlined against the clarity of the sky or the darkness of an interior. In any case, they displayed the linear elegance and the graciously decorative values of the clothing and the adornment of the person portrayed.

The Portrait and the Expression of Virtue

A new type of painting made its appearance during the Renaissance, and portraits were the maximum expression of this art. In a matter of a few years, portraits went from being a detail in a work of religious inspiration to the main theme of many paintings. Central and northern Italy and Flanders were the scenes of this rapid transformation. These portraits were an indirect consequence of the new artistic realism characteristic of the Renaissance, a realism that would reach amazing heights in the Flemish portraits of painters like Jan van Eyck or Rogier van der Weyden. In Flanders as in Italy, these works of art celebrated the virtue of the person portrayed and also his or her more or less ostentatious degree of social status.

Raphael

Of the many aspects of Raphael's art, the production of portraits is among the most outstanding. Raphael is the creator of a type of portrait considered a classical model since then: a figure in a quasi-frontal position cut approximately at the waist. The work reproduced on this page (the *Portrait of Balthazar of Castiglione*) is perhaps his most popular, a painting that powerfully influenced Rembrandt and all the baroque portraits. It has the subtle psychological insight that, from that moment on, was the goal of many great artists.

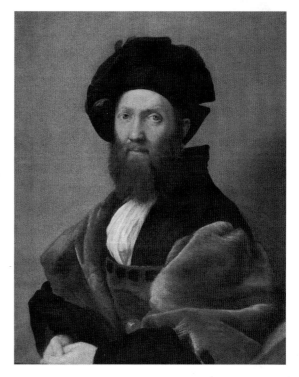

Raphael, Balthazar de Castiglione. *Louvre Museum (Paris, France).*

Baroque Portraits

During the long baroque period (seventeenth and eighteenth centuries), portrait making became established as one of the main genres of painting. Princes, ministers of the church, and the great European lords asked to be depicted in portraits exhibiting the attributes of their power. Painters like Velazquez, Rembrandt, or Rubens (the three great names of European baroque) were primarily portrait artists. There are, though, significant differences among them. While Velazquez and Rubens were court artists, Rembrandt offered the first portraits that were not conditioned by the inevitable adulation that a large commission implied. This painter portrayed friends and family members in works that express a moving intimacy and tenderness, thus introducing a truly modern focus to this genre.

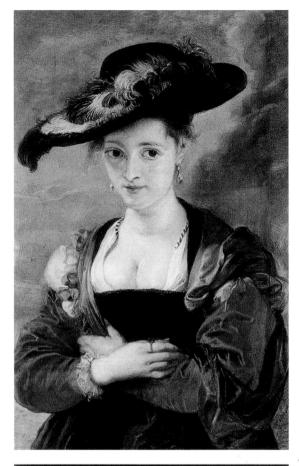

Rubens, Susana Lunden. *National Gallery (London, England).*

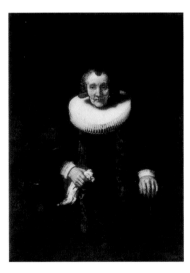

Rembrandt, Margaretha of Greer. *National Gallery (London, England).*

Anton van Dyck, The Painter Martin Rickaert. *Prado Museum (Madrid, Spain).*

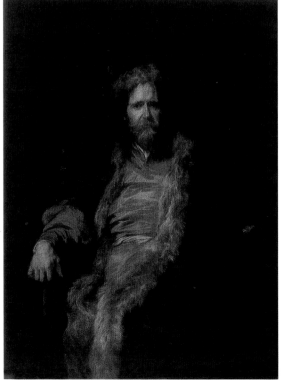

Pomp and Circumstance: The Portraits of Van Dyck

Van Dyck was a pupil of Rubens, and it is from Rubens that he learned how to magnify the elegance and the aristocratic appearance of his figures to a monumental scale. His services were requested all over Europe, and Van Dyck became one of the most successful portrait painters of the baroque. The work of Van Dyck is the perfect model of what the majority of clients look for (then and now) in a portrait: brilliant painting and emphasis on the most attractive aspects of the personality.

From the Enlightenment to Impressionism

French intellectuals opposed (discreetly at the beginning, openly after the revolution) anything that reminded them of the ancient regime. This, in painting, included the baroque style as well. The intellectuals demanded sobriety and simplicity. They proclaimed an ideal for a tolerant and cultivated bourgeois life. This, on one hand, produced the neoclassic portrait, whose main precursors were Louis David and his pupil Jean Auguste Ingres. On the other hand, it focused on a commonplace realism represented by Jean Siméon Chardin. These three painters were the main representatives of the bourgeois portrait of the end of the eighteenth and beginning of the nineteenth centuries. Each in his own way offered wonderful alternatives to the large-format portrait represented by Van Dyck and his very many followers. The neoclassic current became the official one of most of the European countries, while the realistic and commonplace tendency was the one that gave way to impressionism.

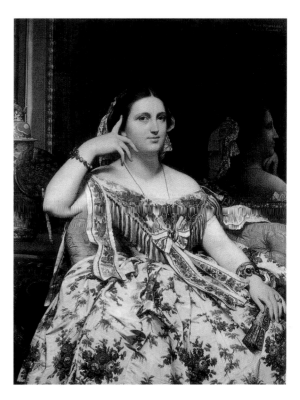

Ingres, Madame Moitessier.
National Gallery (London, England).

Paul Cézanne, Self-portrait.
Kunsthalle (Bern, Switzerland).

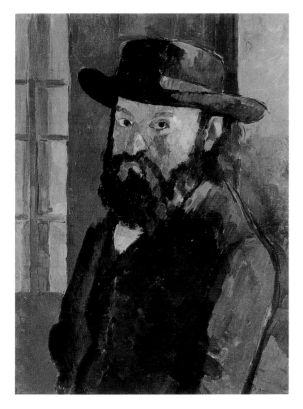

Beyond Impressionism

Many portraits by Renoir, Manet, or Degas, with their charming combination of realistic simplicity and chromatic splendor, deserve to be counted among the great examples of the genre. However, another Impressionist, Paul Cézanne, raised the art of portraiture to a new artistic frontier, synthesizing the direct expression of realism with the constructive rigors of the Renaissance and the baroque. The plasticity of the forms and colors of Cézanne's palette takes the expression of the portrait beyond the limits of a strict resemblance, announcing the artistic audacity of the twentieth century.

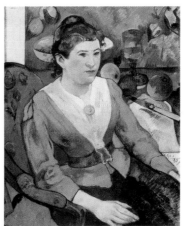

Paul Gauguin,
Woman's Portrait
with Still Life.
*Art Institute
(Chicago).*

The Portrait Today

The twentieth century has been an iconoclastic era. Artists, carried away by innovative enthusiasm, searched for a pictorial essence beyond the representation of nature. In portrait making, this meant an almost total disregard for the conventional resemblance based on the contrast of form and color.

After the first few years of constant experimentation, the art world went in different directions as far as portrait making was concerned, including all the styles, from expressionism to the strictest realism. All these options are still open today, which means that a modern portrait artist has a freedom limited only by what his or her clients are willing to accept.

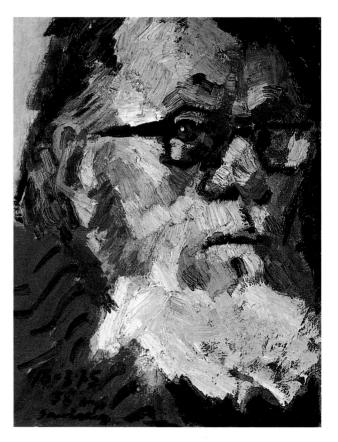

Ramón Sanvisens, Self-portrait. *Private collection. Modern portraits enjoy freedom and experimentation, but the artistic goal is still the representation of a human being.*

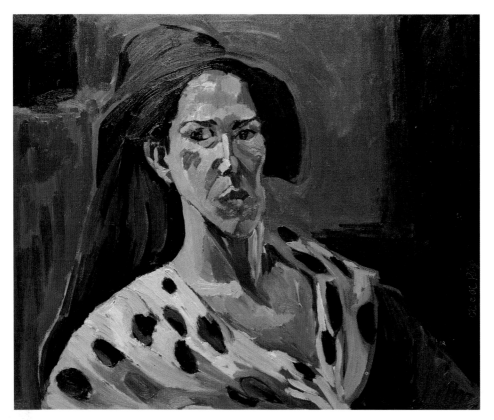

Esther Olivé de Puig, Self-portrait. *Private collection. The innovative attitude of modern portrait artists is manifested with special emphasis in the self-portrait, a field open to experimentation with color and composition.*

Basic Dimensions of the Head

Among the many variations that a human head and face may present are some basic proportions that give the head of a man or a woman its distinctive human appearance. This chapter is dedicated to the study of those constants.

Teaching art, just as teaching anything else, must be based on general practical models. Specific cases can be better understood if there is a model to base them on and that makes them easy to understand. Such is the case of learning how to draw portraits. One must begin with an ideal portrait, working other specific

The following pages present an "ideal portrait" upon which all specific portraits can be based and adjusted according to particular cases

forms from it. The following pages present that ideal portrait. Naturally, this is a generalization. The ideal does not correspond exactly to any person in particular. However, it allows us to learn an appropriate formula to represent real people by making the necessary adjustments.

The model used here is the one that best adjusts to the majority of cases. It is based on dividing the human head into proportional sections. Each one of these sections is a useful reference for the placement of facial features. When the artist masters this basic formula, he or she will be able to draw male and female heads as well as those of children and adults with the correct proportions. This consists of a first essential step for developing the ability of a portrait artist who, before working on creating the likeness, must always resolve the basic problem of how to draw a human head with the correct proportions.

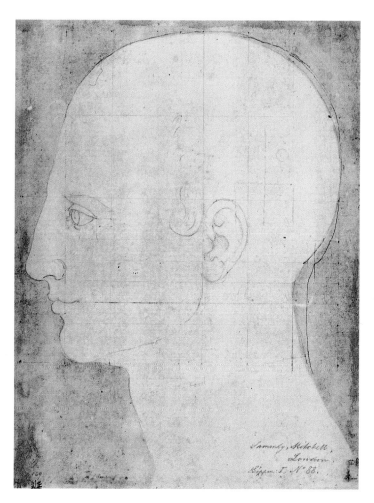

Albrecht Dürer, Profile of a Male Head. J. Pierpont Morgan Library (New York). The basic sketch of the human head explained in the following pages is a variation of the ancient models studied by the great classical artists.

Form and Proportions of the Head

Artists have not always scrupulously respected the natural proportions of the human head and its features. The figures of Egyptian paintings and sculptures follow a particular model that does not conform exactly to reality but that work coherently with the rest of the figure's proportions. The eyes of ancient Greek sculptures are exaggeratedly large and the foreheads too wide. Rather than considering them mistakes, we perceive this artistic license as a means in pursuit of an expressive end.

Real Proportions

The study and application of real proportions to the human head is equivalent to establishing some sort of proportions for each type of head and almost for each person in particular. The shape and size of the jaw varies from one person to another. The same is true for the width of the skull, the distance between the eyes, and the length of the nose. What interests the artist, though, is not the study of each particular case but to have a set of reliable general references. Therefore, a system of proportions must part from the particular reality of each person, establishing instead a standard with which it is possible to draw heads with the correct proportions.

Head of Zeus, Olympia Museum (Greece). Ancient images follow a very different system of proportions from the modern Western images. However, they convey a strong feeling of life, and their appearance is totally convincing.

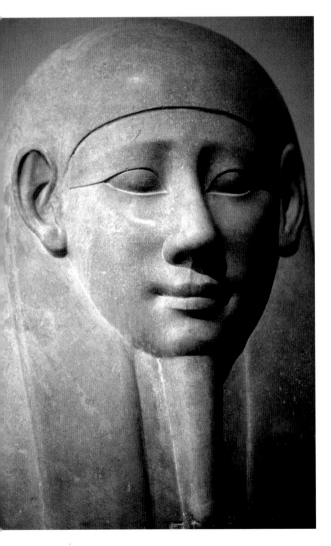

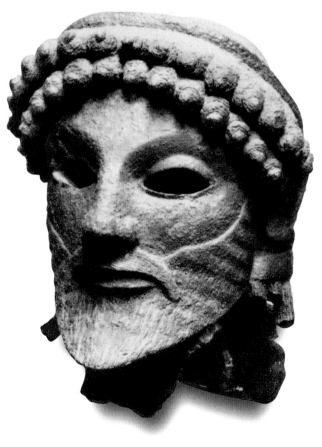

Egyptian statue. Vatican Museums (Rome). The proportions of this Egyptian relief are quite similar to those of the classic European imagery. Even though the system of proportions is completely Egyptian, it has been modified by the artist, who has adapted them to the facial features of the figure represented.

The Standard

The artists of ancient Greece created standard proportions for the human figure, which became a model of perfection for all Western classical art. In this canon, every part was harmonically related to the whole, including the head. Greek artists did not specify ideal measurements for the human head. However, the continuous use of these standards on the part of many generations of artists has established a routine of certain useful proportions for drawing the human head by memory, without the need to consult any models.

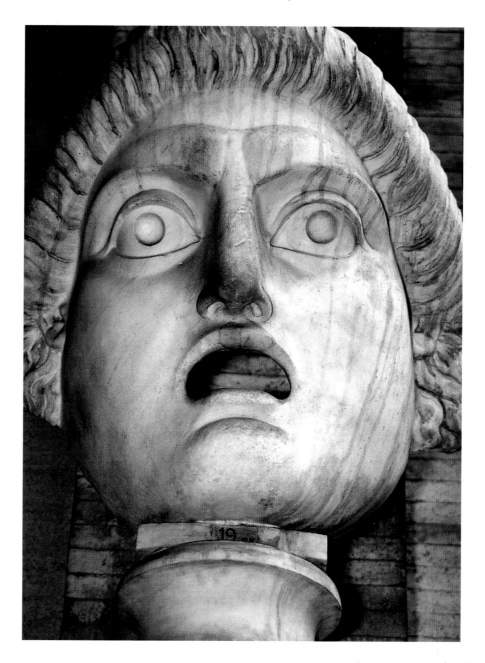

Head of a Roman sculpture. Vatican Museums (Rome). Even in classical statuary, which is a style subject to the strictest canon of proportions, we find examples in which the criterion for expressivity (exaggeration of the features for dramatic purposes) bypasses stylistic rules.

A Reference System

To learn how to draw a head, a face, and portraits, one must begin by studying the dimensions and proportions of the human head. The surest way to study those proportions is to establish a canon or system of general measurements that offers clear references to the artist. It must allow him or her to know at any given time if the work has good proportions or not. The following canon or rules of proportions can be applied to any adult figure. Note that drawing a child's head, which will be studied later, uses different standard proportions.

This is the real model to which the standard of measurements will be applied. The fact that some of the references do not exactly fit in the ideal canon does not make it unusable. As can be observed in the sketches, the basic partitions fit well with the real shape of the head.

The head seen from the front is completely symmetrical. The line of symmetry is the most basic reference for the artist.

The center of the head seen from the front is between the eyes. This is a basic reference that makes it possible to check if the drawing is correct right from its first stages.

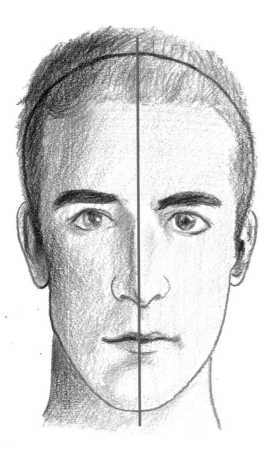

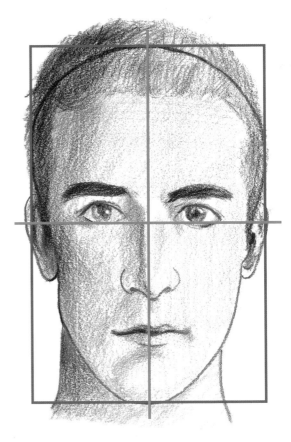

Previous Considerations

Before we study the proportional modules that characterize the head, two basic factors must be mentioned. First, the head seen from the front is symmetrical and that line of symmetry already represents a first reference for the artist. Second, the center of the head seen from the front (considering only the boundaries of the skull, without taking the hair into account) is located at the bridge of the nose, right between the eyes.

PLACEMENT OF THE MOUTH
Once the basic partitions of the head have been established, locating a new useful reference is possible by drawing a new line right in the middle of the lower module (the module that separates the base of the nose from the lower edge of the chin). The lower limit of the mouth is established approximately within that new reference.

Basic Module

As a rule, the height of the human head equals approximately three and a half times the height of the forehead (from the hairline up to the level of the brows). Therefore, the forehead is the basic reference or measurement that determines the proportions of the rest of the parts of the face. We can then say that by dividing the height of the head into three and a half units, using horizontal lines, we get the placement and proportions of the following elements: the upper profile of the head or skull, minus the thickness of the hair; the hairline; the placement of the eyebrows; the height and placement of the ears; the lower part of the nose; and the lower profile of the face or lower edge of the chin.

Left. *The head seen from the front can be divided vertically into three and a half modules. The basic measurement model is equivalent to the distance between the hairline and the level of the eyebrows.*

Right. *By dividing the lower module into two halves, we can get the height of the mouth from the bottom part of the lower lip with acceptable accuracy.*

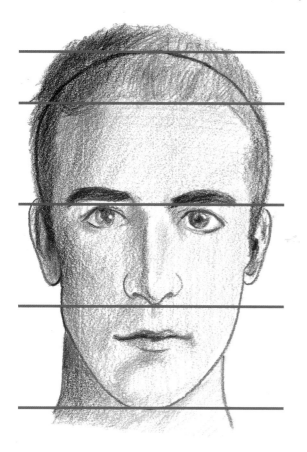

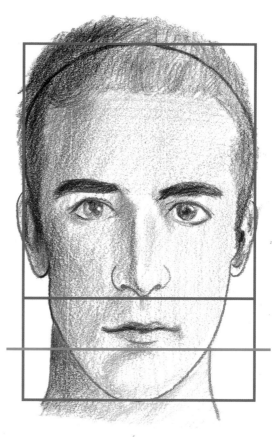

Horizontal Proportions

By applying the same proportion of the forehead to the width of the head, one realizes that it can be divided into two and a half units. By keeping in mind these divisions and the previous ones, the following rule can be established. The height and width of a human head seen from the front are similar to a rectangle that is three and a half units high by two and a half units wide.

For practical reasons, the horizontal partitions are placed from right to left in such way that the half unit remains in the head's left corner.

Distance Between the Eyes

By dividing the largest modules of the partitions into two equal parts, a total of five equal partitions result for the entire width of the head (see the examples below for explanation). You can see immediately that those partitions correspond with incredible accuracy to the width of the eyes, which provides a

NEW REFERENCES
The most relevant horizontal partition is the one that corresponds to the eyes. The first two partitions mark the left sides of the eyes. These vertical references, added to the previous horizontal ones, help indicate the location of the features of the head seen from the front.

new important reference. Also, we can verify that the distance that separates the eyes is equal to one of those partitions, in other words, one partition equals the width of one eye. These two references are very useful when drawing a head seen from the front.

The width of the head is equal to two and a half modules, taking as a module the same dimension used to divide the height.

The width of the eyes is approximately equivalent to half of a module. Also, the distance that separates one eye from the other is equal to the width of one eye (half a module).

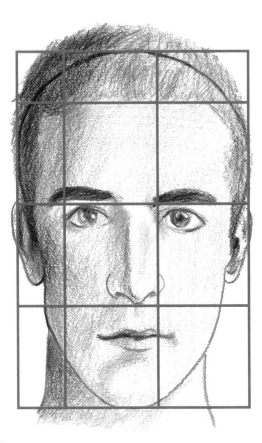

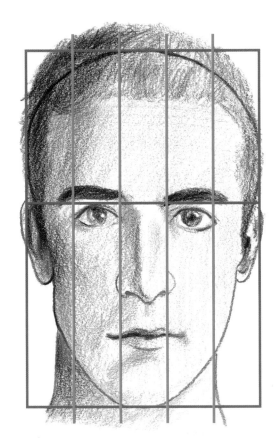

References for the Head in Profile

When using the same module for the head in profile, we notice that a head's total area is three and a half times the height of the forehead. In other words, the head in profile fits exactly into the shape of a square that has the same number of divisions in height and width. The same horizontal divisions drawn on the head seen in profile determine the place in which the eyebrow, eye, nose, ear, and so on should be drawn.

The partitions of the head seen in profile, similar to the case of the head seen from the front, are taken from a real model. This means that the references of the canon are only approximate, but that does not diminish its usefulness.

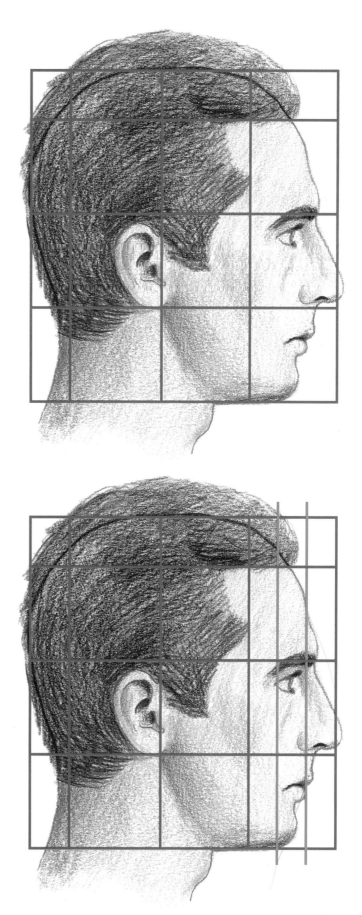

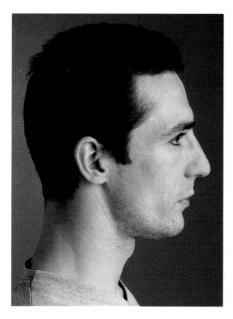

Top right. The head in profile is a square equivalent to three and a half modules wide by three and a half modules high.

The modular divisions of the head in profile help determine the placement of the ear and, after subdividing the first module, that of the eye and the mouth.

The Proportions of a Woman's Head

The dimensions and proportions of the female head and face are essentially the same as the ones studied for the male. The differences are minimal and can be summarized easily: a slightly smaller face than the male, larger eyes, a slightly smaller nose and mouth, and a less angular jaw. As can be seen, all these differences do not affect at all the basic partitions and references studied for the male head.

If the artist has mastered the rules for the male head, he or she should be able to draw a well-proportioned female head. On the other hand, whenever drawing by memory, the artist will have to take into account the basic features that characterize the female physiognomy.

The Proportions of a Child's Head

At two years of age, the forehead of a child is high and does not have a lot of hair. The center of the head is below the brows and not below the eyes. There is a larger distance between the eyes than on an adult's head. The ears are proportionately larger and are located lower than on an adult's head. The chin is rounder and much smaller.

At six years of age, the hair has grown a lot, to the point of covering part of the forehead and the temples. The jaw is more developed, and the face is more elongated than at two years of age. The eyes and the brows have also moved upward, together with the nose, the mouth, and the ears. The chin, however, continues to be delicate in shape and less prominent.

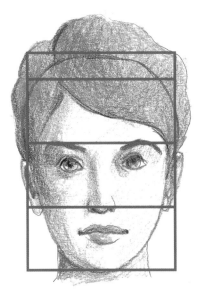

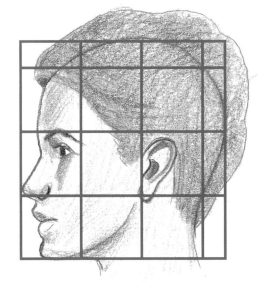

The rules for a woman's head, from the front as well as in profile, are exactly like that of a man's head. Even when working with this similarity, the artist must create the female head with the physiognomy that is appropriate for it.

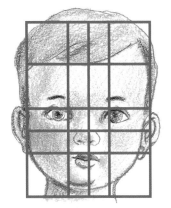

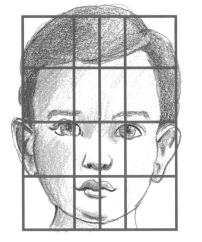

As a child grows, the proportions of the head vary considerably. This illustration shows the proportional schemes of the head of a child at approximately age two and at age seven.

PROPORTIONS OF A CHILD'S HEAD

The general proportions of a child's head seen from the front resemble a rectangle measuring three units wide by four units high. The module is based on the height between the lower part of the nose and the end of the chin. The placement of the eyes is determined by dividing in half the module in which they are located. As in the adult head, the profile of a child's head is also square.

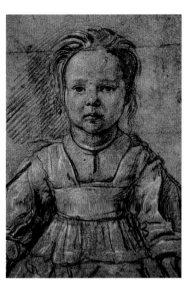

Anonymous, Portrait of a Girl. In this portrait, the artist has emphasized the typical "disproportion" of the child's head with respect to the body. This disproportion is an essential factor in children's portraits.

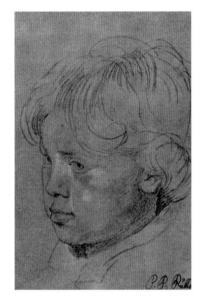

Rubens, Portrait of the Artist's Son. The rounded shapes of a child's head are successfully represented in this magnificent drawing. The artist has enjoyed drawing the characteristic rounded lines of a child's face.

Adolescence and Adulthood

At approximately 12 years of age, the hair continues to be as full as at age seven or eight, still without indications of the pronounced thinning around the temples characteristic of adulthood. The eyes and the brows have not reached the center of the head yet. The ears are completely developed, although they are still located somewhat below the level of that of an adult. The bone structure of the lower jaw begins to become more defined, so the jaw is not as rounded as it was in childhood.

At 25 years of age, the head has reached the proportions of adulthood. The eyes are located at the center of the head, and the contours have become more angular.

In adolescence, a child's head begins to approach the characteristic proportions of an adult head, which is permanently established at age 25.

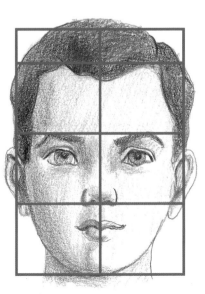

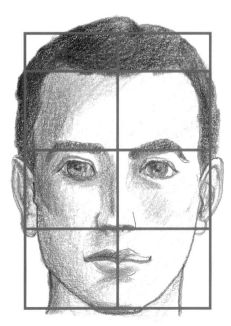

PORTRAITS OF ELDERLY PEOPLE

The portraits of elderly people offer more artistic possibilities than the portraits of people of any other age. First, the features are much more pronounced, so they offer many more points of reference for their placement while constructing the head. The angles and prominent features are significant data that emphasize the resemblance. Second, the expressions of elderly people are charged with experience and humanity. All the facial features illustrate the passage of time, that is, the passage of life.

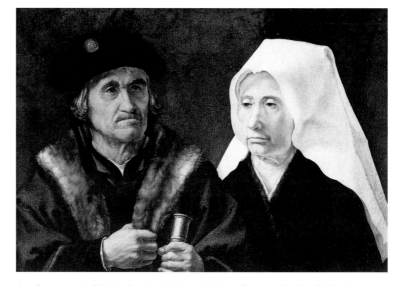

Jan Gossaert, An Elderly Couple. *National Gallery (London, England). The faces of advanced age offer many more references for characterization than young faces. The marked features of these two figures make their portraits resemble a caricature.*

The Head in Old Age

There is no variation in the proportions of an elderly person's head from those of a younger adult. Certain peculiarities produced by the passage of time, though, are indicated here. During the elderly years, there is a tendency to baldness, which results in the clearing of the forehead and a prominence of the bony mass of the skull. The temples become more angular, the eye sockets deepen, and the ocular cavities become more pronounced. Brown bags and wrinkles appear around the eyes, and the relief of the cheeks becomes more accentuated and protrude from the somewhat contracted cheeks. Also, the lips become thinner, and folds and bags appear under the chin and in the neck.

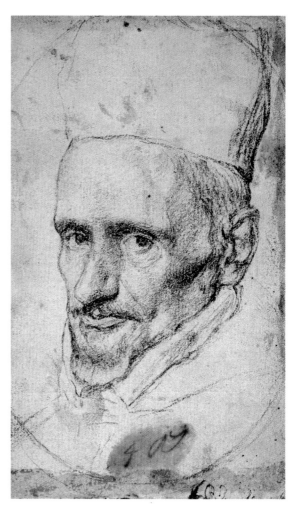

Diego Velázquez, Cardinal Borja. *Prado Museum (Madrid, Spain). This magnificent drawing summarizes all the significant facial features of old age: clearing of the forehead, marked temples and cheeks, and eyes sunk in their sockets.*

Study of Facial Features

There is no point in using the proportions of the head correctly if it is not completed with something as vital as the facial features. This chapter offers a careful review of each facial feature with detailed instructions on how to draw them.

Before we go on to develop the details in drawing a complete head, we must pause to study the facial features. Facial features form a whole with the face and the skull. The physiognomy is a unified grouping, and only fantasy can imagine a person with a different mouth or eyes. To make drawing a human head easier, studying each of the facial features separately is essential. The following pages offer a hands-on approach to each one of those features and include practical instructions on how to work on each

◆

The following pages offer a hands-on study of the facial features and include practical instructions on how to resolve each one of them correctly.

◆

one of them correctly. At first sight, drawing the eyes, the mouth, or the ears may look complicated. By keeping in mind a few clear concepts, though, the task is much simpler than it may originally appear. A good resolution of the features depends almost entirely on the ability to observe and on the distribution of light and shadows. What the reader will find in the following pages is advice on how to observe and clear indications about what is relevant and what is not, that is, what has to be kept and what has to be ignored.

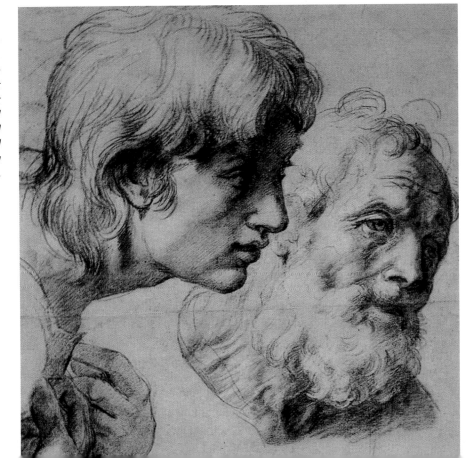

Raphael. Study for the Transfiguration (fragment). Ashmolean Museum (Oxford, England). These drawings were, most probably, done without a model. Raphael worked from his solid knowledge and experience in drawing facial features.

The Eyes

As shown in the previous chapter, the eyes are located in the center of the head, symmetrically aligned just below the line that marks the lower border of the forehead, that is, below the eyebrows. This is basic. Another basic observation is that both eyes move in perfect coordination, that is, they move in the same direction. This movement is called the direction of the gaze. The human eye is a sphere (eyeball) located in the eye socket and covered with the eyelid. The artist must keep this spherical and symmetrical condition of the eyes in mind at all times, because the accuracy of the drawing depends on this point. The shapes of the eyelids and the brows are secondary aspects that must be considered once the coordinated movement of the eyeballs has been established. If the artist worries too much about these elements in a realistic drawing without having resolved the main concept, he or she runs the risk of disfiguring the expression.

FORESHORTENING OF THE EYE
Foreshortening means representing objects in perspective. To represent a foreshortened eye means to draw it in a position other than the frontal one. The problems that the artist may encounter doing this are solved more easily if he or she keeps in mind the spherical shape of the eye: a sphere surrounded by an oval opening. Knowing how to draw that sphere, in any position, enables the artist to draw eyes from any point of view.

The top row shows four different positions of the eyeball. Each one these positions affects the way that the iris and the pupil look (like two concentric circles when seen from the front and like ovals when seen in foreshortening). The center row repeats the previous positions of the eyeballs covered by the shape of the eyelids. Thanks to all these diagrams, it is easy to understand and to represent eyes in foreshortening correctly, like the ones shown in the bottom row.

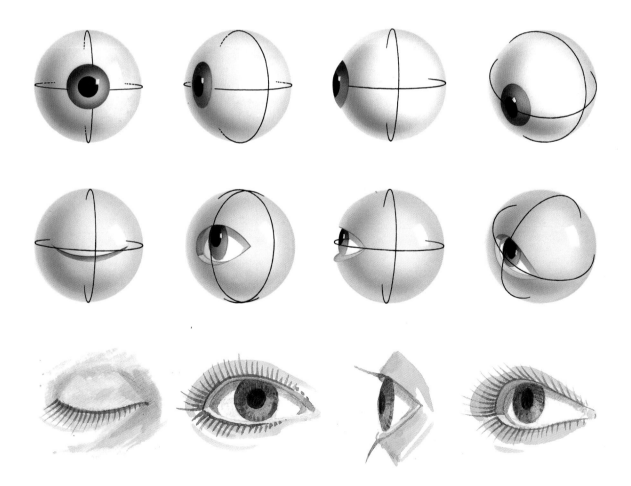

The Eyebrows

The eyebrows are located on the upper edge of the orbital cavity, and their shape tends to replicate the square form of that edge. As a general rule, representing the eyebrows with two symmetrical lines that describe a slight curve is acceptable. In most cases, though, the eyebrows present a slightly different aspect. Often the curve turns into a more or less open angle. In many cases, the eyebrows are more like two straight lines than two curves. Generally, drawing the eyebrows of a woman is easier because women tend to shape their eyebrows with tweezers. In any case, the brows are a vital factor in the characterization of a portrait and, especially, in the representation of a facial expression.

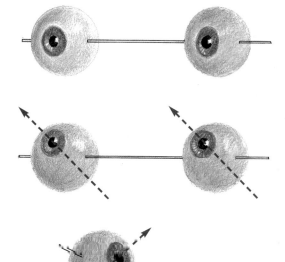

The eyes move in coordination like two spheres rotating on an axis. The correct representation of the eyes requires that the artist must always keep this basic concept in mind.

The correct representation of the gaze depends on the perfect coordination of both eyes.

To draw the eyes and the brows correctly, one must imagine them as a group of interrelated forms, the brows being segments of a sphere that surrounds the eyeball.

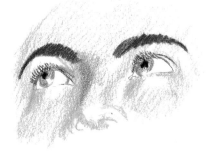

Drawing the Eyes

Once the shape of the eyes and how that shape determines their movement is understood, it is a good time to talk about certain practical matters related to drawing. By observing the eyes carefully, we see that the volume formed by the eyelids is as large as or larger than the spherical shape of the eyeball. The artist must understand and represent that volume properly to avoid the typical deformed look of the portraits made by inexperienced beginners.

When seen in profile, the eyeball is mostly hidden by the slightly bulgy eyelid, which protrudes more in the upper lid than the bottom. This bulging is more visible if the person portrayed is of an advanced age.

A very common mistake is to draw the upper lid of an eye seen from the front with the exact same curvature as the lower lid. In reality, the latter is softer and moving away from the eye. Equally common is the mistake of drawing the foreshortened eye as if it were a flat surface and not curved, as it is in real life.

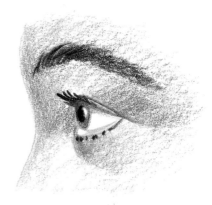

When seen in profile, the spherical volume of the eyeball is almost unnoticeable, while the bulgy shape of the lids (especially the upper one) is what characterizes the volume.

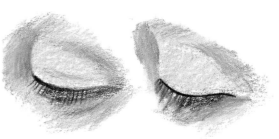

Even when the eyes are closed, the curved surface of the eye, which in this case has been wrongly represented on the drawing on the left, is apparent.

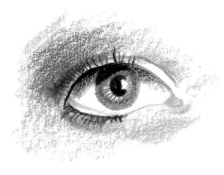

Drawing the upper lid like the lower lid is a common error. In real life, the lower eyelid is even further displaced, as it appears in the drawing above.

THE EYELASHES

The eyelashes of both lids do not fill up their entire perimeter. Instead, they appear fuller toward the outer part of the eye. They are also longer and more abundant on the upper lid than on the lower one. They should never appear exaggerated. The artist must always keep in mind that they are more visible when the eye is drawn from the side.

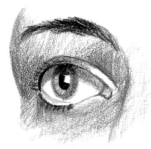

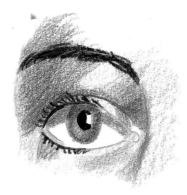

The illustration on the right presents a drawing error. The eye, seen from its side, occupies a curved surface, like the drawing on the left.

Volume, Light, and Shadow

To resolve the modeling of an eye seen from the front, the artist must keep in mind the series of forms that play a part: the upper lid, the eyeball, and the lower lid. The drawing process should begin with an outline of the contour of the eyelids and the iris (which is always partially hidden by the upper lid unless the eye is exaggeratedly open). Modeling consists of shading the edges of the upper lid to highlight its bulge clearly. The same is done with the lower lid but to a lesser degree. Leaving a clear area inside the lachrymal gland is important so the eye does not look like it is pushed against the nose. A strip of shadow on the upper part of the eyeball should be projected by the upper lid and its lashes. That strip should be darker in the area of the iris and should blend with the black of the pupil. Precisely in the area of the pupil, one or two intense points of light are created. They give a touch of life and create the feeling that the person portrayed has a unique look.

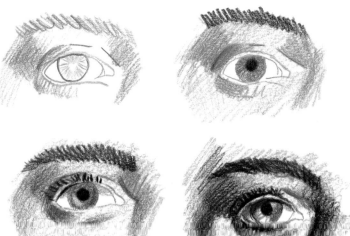

This sequence shows the process of how to draw an eye, from the first lines to the final definition of its volume and shading of the eyeball, the iris, and the pupil.

THE IRIS AND THE PUPIL
The pupil is always black, completely black, and in it one can perceive the peculiar brightness that gives vitality to the gaze. The iris can be varied in color, but it is never perfectly uniform. In most cases, the color is darker on its outer part. In addition, the iris has the peculiar radial lines that provide its characteristic texture. Those lines should be drawn first so they form an integral part of the general color. Finally, one must remember that the "white of the eyes" should always be shaded lightly (on the side opposite the light) to highlight its spherical shape.

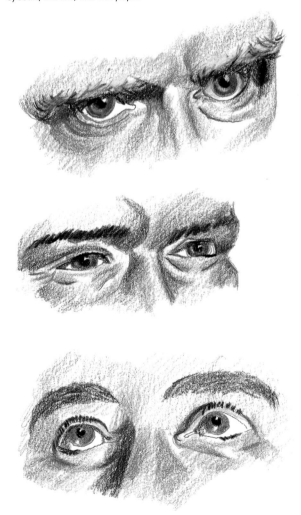

Once the basic notions of how to draw the eyes are understood and practiced, it is possible to resolve any particular case regarding the direction of the gaze of the eyes as well as the creation of the volume of the lids.

The Lips and the Mouth

With the mouth closed, the lips occupy a curved space similar to the eyes. However, it is an area more irregular because neither the lower lip nor especially the upper lip present a uniform and continuous surface. The upper lip is defined by the characteristic fold in the middle. It is slightly longer than the bottom lip. The lower lip is fleshier than the upper one, and it also has a small furrow in the middle. The characteristic drawing of the lips is dictated by two factors. First, a sinuous line separates them (when the mouth is closed), which can be straighter or wavier depending on how tight or relaxed the expression is. Second, the relative thickness of each lip is characteristic: the thicker the lips, the deeper the corners.

PAINTED LIPS

The considerations regarding the shading of the lips change when the lips are painted, as often happens in female portraits. In such cases, the shading of both lips is darker and without as many differences between the upper and lower area. It is important to point out that the glossiness of the lower lip can be more visible in painted lips. That shininess is precisely what differentiates them in monochromatic drawings.

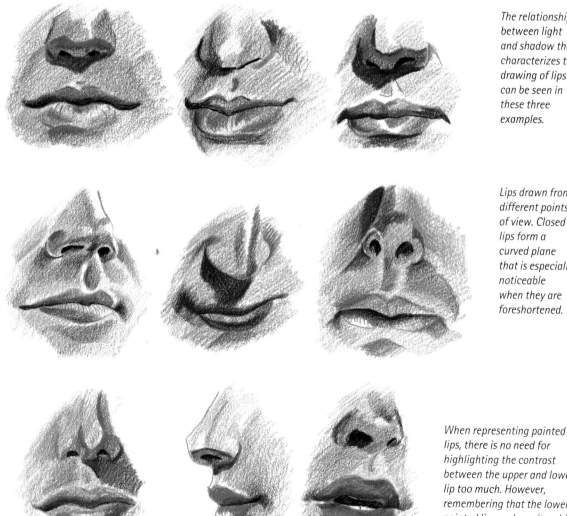

The relationship between light and shadow that characterizes the drawing of lips can be seen in these three examples.

Lips drawn from different points of view. Closed lips form a curved plane that is especially noticeable when they are foreshortened.

When representing painted lips, there is no need for highlighting the contrast between the upper and lower lip too much. However, remembering that the lower painted lip can be quite a bit shinier than one that is not painted is important.

Light and Shadow

Under normal light, the upper lip always looks more shaded than the lower. It is important to remember this to avoid the flat and cutout look of the lips seen in some portraits done by less experienced artists. Also, the lips' outer border should not be outlined. Instead, it should be made visible using the play of light and shadow. Precisely, the contour of the base of the lower lip can be created with the shadow projected on the chin. A reflection or light area is also characteristic of the middle part of the lower lip because it is fleshier. Finally, the shading of the upper lip must not be uniform but darker in the middle furrow at the corners of the lips than on its upper area.

LAUGHTER
Representing laughter is much less common in a conventional portrait, but it merits certain consideration so the artist knows how to draw it. During the act of laughing, the mouth opens in such way that the upper teeth are revealed. One must resist the temptation of drawing them individually by marking their separations too much, because the result can be quite unpleasant. The open laughter also reveals the tongue and the inside of the mouth. The artist should not spend too much time drawing them. The lower edge of the teeth should simply be properly darkened and the tongue shaded a little bit.

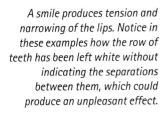

A smile produces tension and narrowing of the lips. Notice in these examples how the row of teeth has been left white without indicating the separations between them, which could produce an unpleasant effect.

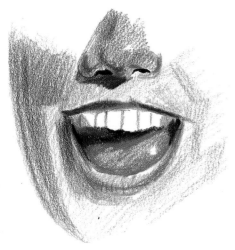

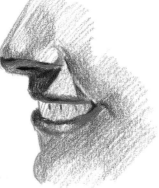

Laughter creates tension in all the muscles around the mouth. To achieve a good representation of an open mouth, the area below the lower edge of the teeth must be darkened considerably.

The Nose

Drawing the profile of the nose is very simple once the diagram of the head has been properly laid out. However, things begin to get complicated when the drawing consists of a three-quarter or front view. Then the angle becomes less and less evident until it blends in a series of irregular forms, light, and shadows. The key to drawing the nose when it does not have a clear profile is to replicate the set of light and shadows literally, keeping in mind certain considerations. First, the lower part of the nose is shaded. However, its shadow is less intense than the area immediately above it, which corresponds to the most outstanding area of the edge of the nose. Second, the bridge of the nose always has an elongated shiny area, which helps represent its relief. Finally, the transition between the nose and the forehead in young people hardly presents any significant variations in shading, but it is more marked in older people.

These series of illustrations show how to resolve a drawing of the nose seen from different angles. The more frontal the point of view, the harder the drawing will be because the contour gives way to a series of lights and shadows.

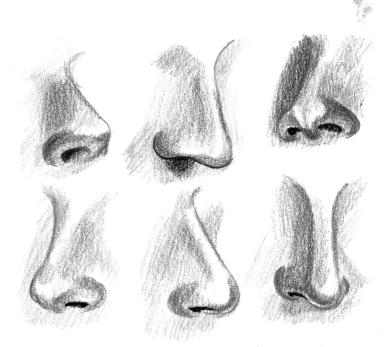

THE EFFECT OF LIGHT
On a head viewed from the front, the profile of the nose depends entirely on the type of light. Light that is completely projected from the front will wash out the bridge of the nose and will reveal only its bottom and sides. Side lighting dramatically changes the appearance of the nose until it makes the nose look like a true dividing line that separates the lighted area of the face with the part that is in the shade.

It is important to practice drawing noses from different points of view: the front, the side, the three-quarter view, and from above and from below until you familiarize yourself with the different characteristic configurations of light and shadows.

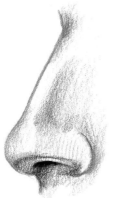
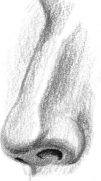
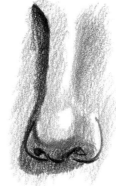
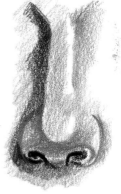

The Ears

To resolve the ears properly, you need only to approximate their basic structure: their oval shape and concave volume. Also, you must keep in mind that the ears, as seen from the front, are a continuation of the facial plane. From the back, though, they clearly rise above the plane of the nape. Other than that, the complicated interior relief of an ear must be represented carefully, paying attention to its basic features: the lower lobe and the edge that surrounds the upper contour. When looking at a face from the front, the artist should remember the significant internal contour, which stands out more or less clearly depending on the person.

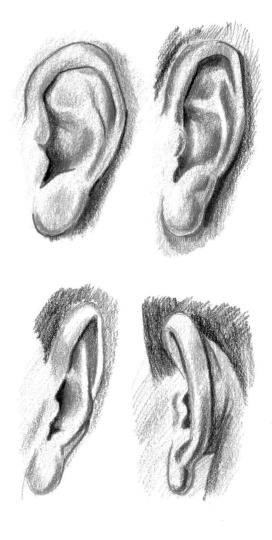

The ears have a complex form. The lobe and the upper crest are quite constant, but the inside shape varies considerably from person to person. The frontal point of view (frontal view of the head) and back views may be the most problematic for the artist.

THE EARS AND THE RESEMBLANCE
Of all facial features, the ears have the least significance for approximating a person's likeness. It is enough to adjust their size to make them appear as if they are in "their place"; there is no need to copy them exactly. Observing classical paintings and sculptures is helpful. Notice that the ears are always drawn the same way by nearly every artist, regardless of the person being represented. What is important is for ears to be placed correctly in the general scheme of the head.

Ear studies seen from different points of view, giving special consideration to the head and its relationship to the face and neck.

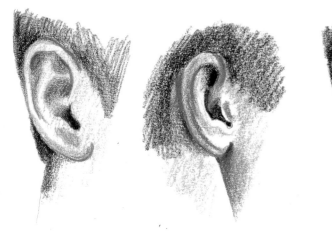

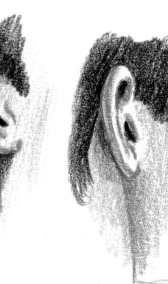

The Hair

The hair, as important as it may seem for achieving a person's resemblance, occupies the last place in the group of physical factors. Amateurs usually place too much importance on the hair, only because it contrasts vividly with the face or because it occupies a large volume. This tends to make the artist neglect aspects of proportion, placement, and form of the facial features to the point where the latter are too conditioned by the overworked hair. The hair must be drawn once the head and the face have been appropriately resolved. If that part of the composition is correct, drawing the hair will not present too much difficulty.

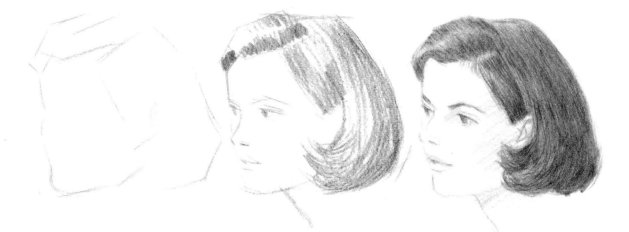

Blocking in and resolving the hair is not as complex and rich in details as the face. It must be done, though, by paying great attention to the general contours of the hair so you can later work on the shading without compromising the general structure of the head.

TONAL CONTRAST
Dark hair creates intense contrast with respect to the lightness of the skin. That contrast, though, must be softened by blending the tone of the skin (in an area of shadow) with the hair in one or more areas of the face. If this is not done, the hair will look like a wig or an ill-fitting toupee because the contrast will be too strong. On the other hand, the play of light and shadow on the hair must never contradict the structure that supports it, that is, the skull. The hair must fit on the skull naturally.

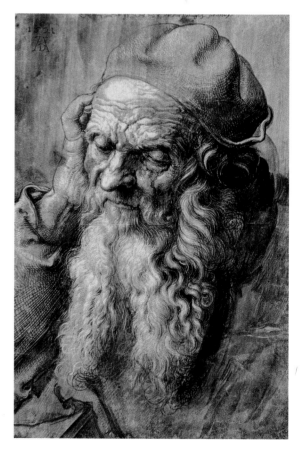

Albrecht Dürer. The powerful volumetric block of this magnificent head was conceived as a unity, in which the hair was simply an excuse for heightening the creative effects. There is no substantial difference between the tone of the hair and the face, between light and dark tones.

The Working Process

Representing the hair, by drawing or painting, generally presents problems of shape, highlights and reflections, light and shadow, tonal value, and direction of the line or the brush stroke. These problems can be easily solved if the artist begins by adjusting the general mass or volume of the hair in correct proportion to the skull. This is followed by a preliminary placement of light and shadows, paying attention to the direction of the line and leaving the areas with more light untouched. The shading should darken the entire composition gradually, drawing the lines or placing the brush strokes following the direction of the hairstyle. You must remember to keep the surface of the hair even and to draw the strands separately so the result does not appear rigid.

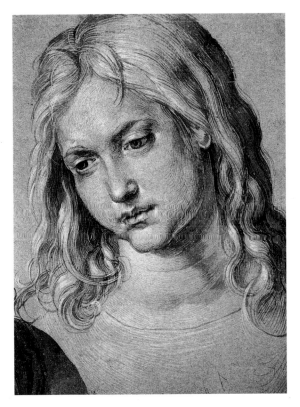

Albrecht Dürer. The strands of hair in this figure have been drawn in a strong decorative manner, but their tonality hardly differs from that of the face. This reduction of contrast between light and shadow gives the entire composition a powerful sense of unity.

During the portrait-making process, darkening the hair before painting the color of the face produces an artificial effect, making it look as if the model is wearing a wig.

Throughout the process, the artist must model the color correctly, so the darkest areas have a tone similar to the color of the hair and the lightest areas resemble some of the skin tones.

The Neck

Of all the partial studies done up to this point, the representation of the neck is of secondary importance. When drawing the head, though, introducing some reference to the neck will be necessary. Often, the position of the neck helps the artist indicate the correct position of the head. In any case, drawing the head without any indication of the neck feels awkward. From the point of view of the general scheme of the drawing, the neck is simply a cylinder inserted into the head's sphere. Therefore, its placement is not difficult. Generally, problems arise when working with the light and shadows of the drawing. The upper part of the neck must always look more shaded than the face—this makes the neck look as if it were inserted at the base of the skull.

THE NECK AS AN ORNAMENTAL FEATURE
In Western as well as in Eastern art are many examples of portraits in which the stylization of figures for ornamental purposes is achieved by creating exaggeratedly elongated necks. The effect of this obvious disproportion produces great elegance. Artists used this trick to emphasize the aristocratic identity of the people portrayed. Even in more modern times, painters like Ingres or Modigliani used this feature to convey a sense of gracefulness and distinction to their female portraits.

To achieve a good connection of the neck at the base of the skull, contrasting the values of light and shadow is important so the darker areas of the neck contrast with the light areas of the face and vice versa.

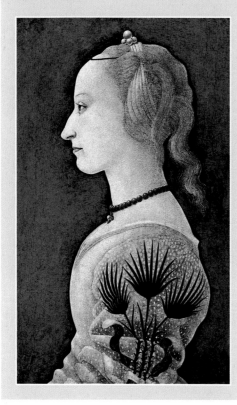

Alesso Baldovinetti (1426–1499) Lady in Yellow. *National Gallery (London, England). In this courtesan portrait of the Renaissance, the painter has indulged in exaggerating the length of the neck to convey a distinguished look to his figure.*

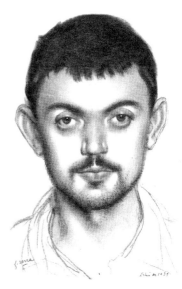

Frencesc Serra, Portrait of a Young Man. *Private Collection. The transition from the neck to the head is resolved here with the darker tones of the beard, which separate the face from the neck.*

Blocking In and Constructing the Head

The front and side views are the two basic representations of a human head. However, any competent artist should be able to draw heads from any point of view.

After the overall proportions of the head and the shape and placement of the features have been established, the artist should be able to solve all the basic problems for drawing the head and the face. Up to this point, drawing the head has not gone beyond the two basic views: front and side. The following pages will explain and put into practice a method that is very easy. It consists of drawing heads in any position and from any point of view by applying what has been learned before. This means that from the study of the

From the study of the "ideal portrait," we will go on to the creation of specific portraits, no matter the pose adopted by the model.

"ideal portrait," we will go on to the creation of specific portraits, no matter the pose adopted by the model. The method used is extremely simple. It is based on the combination of basic shapes: spheres, circles, ovals, straight lines, and curved lines. The only thing required of the artist is a little bit of spatial imagination, or simply the ability to imagine forms from various points of view. With this basic ability and with the practice we have had until now, the technical problems that arise when drawing heads can be easily resolved.

This chapter shows the usefulness of some simple blocking-in methods for drawing a head.

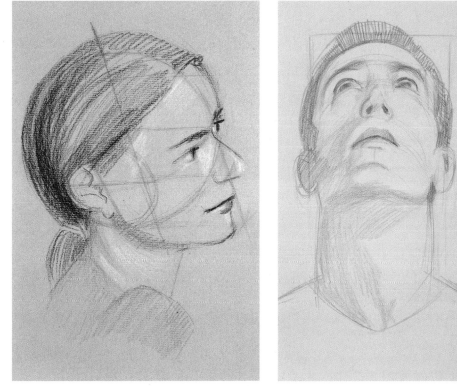

Practical Construction Method

The practical method proposed here is suggested by the anatomy of the skull itself, the basic blocking in of which may begin with a sphere. This sphere, however, overlaps the real shape of the skull and does not contain the skull in its entirety. In fact, the skull, as seen from the front, appears shorter on the sides, while its profile view is modified by the prominent volume of the jaw. To block in the shape completely using a sphere as a model, a slightly tilted line can be drawn (tilted at the same angle as the jaw) to locate on it the modular divisions studied in the previous pages. A module goes from the chin to the base of the nose, another from the base of the nose to the area of the eyebrows, an additional one up to the beginning of the hairline, plus half a module from that point to the upper part of the skull. These divisions can be created either for the side or front view.

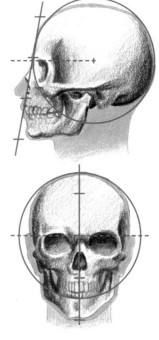

The skull can be laid out using a sphere. A good reference for applying the modules learned in previous pages is made by drawing a line tangent to that sphere, which runs the length of the jaw. With this simple plan, one can draw the head from any point of view.

This sequence shows the initial development of the sketch in three dimensions. First a sphere is drawn (A); then the two meridians are added (B); next the equator of the sphere is drawn (C). The side sections of the sphere are drawn as if they were flat surfaces (D), and the front meridian is extended downward (E).

A

B

WITH AND WITHOUT A MODEL
This method of construction is very useful when working by memory, without a model. However, it is also helpful when using a model (a photograph or live). It makes organizing all the forms easier and allows all the features to be arranged coherently.

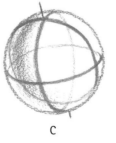

C

D

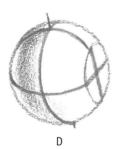

E

After the sphere has been developed, the axis is drawn, marking on it the proportional partitions of the skull parting from the center of the sphere or from the central point of the axis (F). The partitions must be placed on the extension of the front meridian (G). The various facial features are placed on the marks indicated on the vertical line (H).

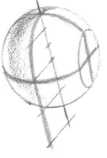

F

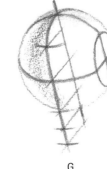

G

H

Developing the Method

Look at the shape of the sphere. We should imagine the sphere slightly tilted to the side, drawing the axis diagonally with respect to the vertical. To help arrange the features correctly, the sphere's equator and the meridian that divides both its "poles" are drawn. Given that the sides of the skull are flat, the sphere must also be flat, as if the two side sections were sliced off. Now the sphere's meridian must be extended downward, taking into account the line that marked the direction of the jaw. This is the line where the proportional divisions of the head can be marked. These divisions must be drawn on the sphere's axis and must be extended to the elongation of the meridian. By doing this, the basic arrangement of the features is solved. With what you have learned about how to draw the eyes, nose, and mouth, resolving the face by following previous guidelines will not be difficult.

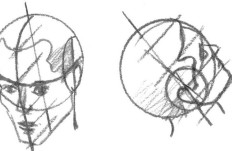
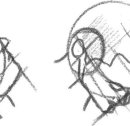
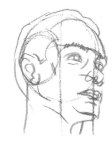

This method for planning the head makes drawing it from any point of view possible.

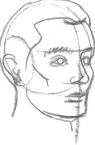
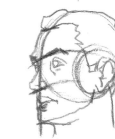

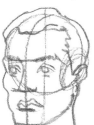

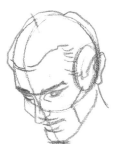
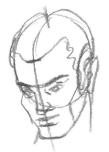
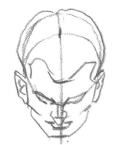
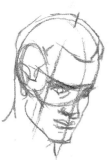

These are some examples of heads drawn without a model, from the sketches placed in different positions. The success of this type of drawing, done by memory, depends on how experienced the artist is in drawing facial features.

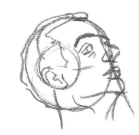

39

Woman's Head Raised

The first of the brief exercises that follow consists of drawing from a picture a woman with a raised head who is looking up. The blocking-in method studied in the previous pages will be applied, always keeping in mind the shape and volume of all the features.

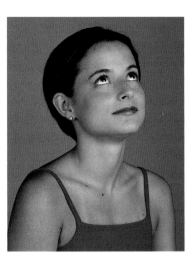

From this point of view, the shape of this woman's head resembles the shape of a sphere. This is an advantage because deviating too much from the initial plan will not be necessary to draw the face.

MATERIALS
- Colored pencils
- Sepia and sanguine pastel pencils
- Gray paper

```
TECHNIQUES USED
```
- ◆ Proportional division of an adult's head ◆
- ◆ Drawing the features ◆
- ◆ Blocking in the head ◆

1 The first and a very important step consists of drawing the sphere and marking its axis according to the angle of the head. If this angle does not agree with the angle of the model's head, the entire drawing will reflect the error.

2 Next, the sphere's equator and its front meridian are drawn, extending them correctly with a line parallel to the sphere's axis.

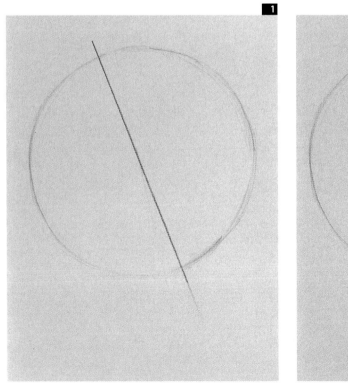

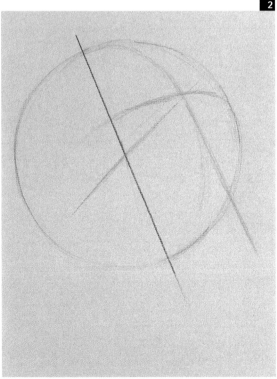

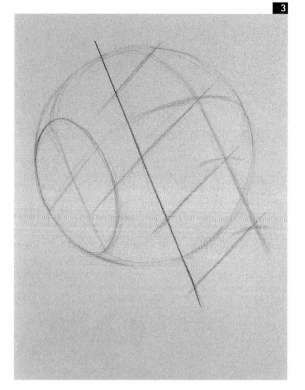

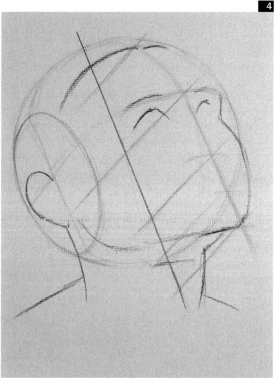

3 The sides of the sphere are flattened. The proportional partitions are marked on the axis, beginning at the center of the sphere. This point has to be located approximately, keeping in mind the perspective of the entire composition. Next, those marks are extended on the line.

4 Now there are enough references to begin constructing the head by copying the model's features and adapting them to the proportional partitions previously established.

5 Finally, the features and the volumes of the face are shaded a little, remembering everything that was covered in previous chapters about how to model the facial features.

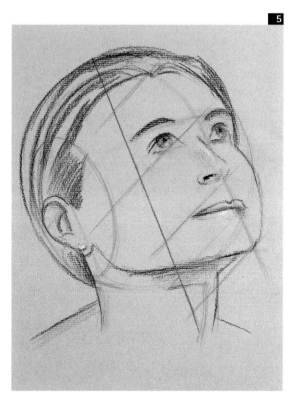

LINES IN FORESHORTENING OR PERSPECTIVE

Probably this exercise will not turn out right the first time. That will most likely be due to the fact that the sphere, the axis, and the proportional partitions were not drawn correctly. Before drawing the shape of the face, it is very important to make sure that the foreshortening or perspective of the plan is close enough (it cannot be exact because it is done freehand). The blocking-in errors become visible only when the artist begins to draw the features. If there are considerable errors, you should redraw the initial plan until its resemblance is convincing.

Woman's Head Seen from Above

This exercise poses a problem very similar to the previous one. In this case, the head is seen from above but from a point of view that is quite similar to the one covered in the previous drawing, so the planning for this profile is similar to the previous one but in reverse. Other than that, the process does not present any significant variations.

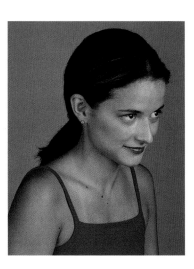

Other than the blocking-in problems that it may offer, this head presents some interesting aspects, like the movement of the eyes or the foreshortening of the nose and mouth.

MATERIALS
- Colored pencils
- Sepia and sanguine pastel pencils
- Gray paper

1 The sphere's axis must tilt in the opposite direction from the previous exercise, keeping in mind that this axis extends upward and that we are seeing the sphere from its "south pole."

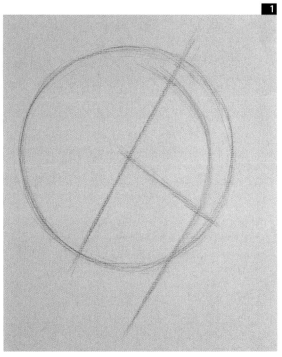

1

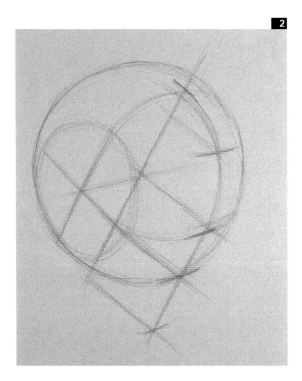

2

2 The equator and front meridian are drawn according to the perspective of the sphere, that is, extended upward. Once the sphere's center has been marked (always located on its axis), it is extended outward with a line whose angle must also correspond to the perspective of the entire composition. The marks of the proportional partitions are then added.

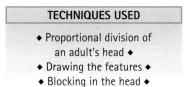

TECHNIQUES USED
- ◆ Proportional division of an adult's head ◆
- ◆ Drawing the features ◆
- ◆ Blocking in the head ◆

PLACEMENT OF THE PROPORTIONAL MARKS

The proportional marks, that is, the lines that indicate the three and a half modules that define the height of the skull, must be drawn on the axis parting from the fixed central reference of the sphere. You must remember that a module and a half should fit between that point and the top edge of the sphere, which is the same as dividing that top segment into three equal parts. The top part is the half module. The two bottom ones equal one module. When you know the size of one module, it is easy to slide it to the lower segment of the sphere until the two remaining modules are located. Keep in mind that the lower module always protrudes below the limit of the sphere because it corresponds to the lower part of the chin.

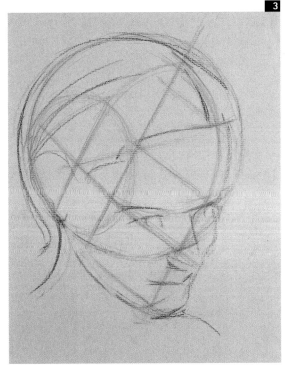

3 After all the references for the blocking in have been worked out, including placing the flat area of the sphere's side in a position that is coherent to the perspective of the entire composition, the drawing of the lines that characterize the face of the model can begin.

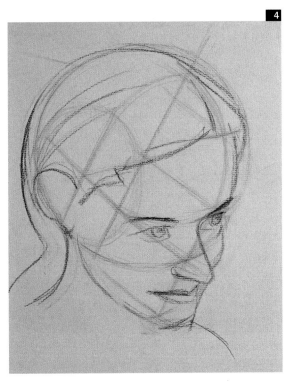

4 Make sure that the various foreshortened views of the features are well thought out and that each feature occupies a correct place within the composition. After making sure that all the basic lines are put in place, shading begins.

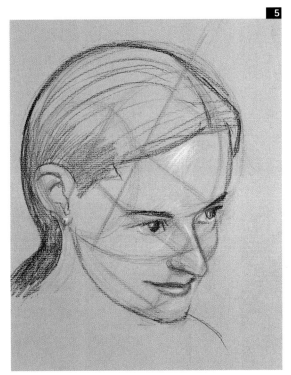

5 The resemblance is easily created if the work is based on a sketch conceived correctly and proportionately.

Woman's Head with Side Foreshortening

This exercise develops the drawing of a head from a side view and from slightly above. The head is not completely in profile but slightly tilted toward the viewer. The foreshortening of the features is not too marked. To be able to work them correctly, it is important to make a sketch to block in the position of the head correctly.

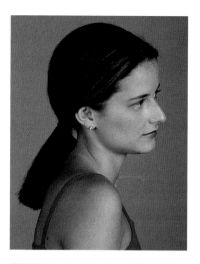

This exercise consists of drawing the figure in the picture. The position of the head presents several aspects: a slight tilt toward the back and to the right side of the model. These two angles are combined with a slightly elevated point of view of the entire composition.

MATERIALS
- Colored pencils
- Sepia and sanguine pastel pencils
- Gray paper

TECHNIQUES USED
- ◆ Proportional division of an adult's head ◆
- ◆ Drawing the features ◆
- ◆ Blocking in the head ◆

1 Blocked-in sketch of the position of the head. The tilt of the sphere is dictated by the position of its axis. The sphere itself is always drawn the same way. When the adjustment of the tilt is completed, the remaining lines are drawn according to the perspective of the equator and meridian.

2 Next, the marks that divide the proportional shapes of the head are projected. Remember that these projections must always be parallel and must originate in the axis.

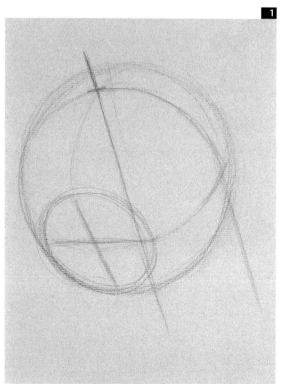

1

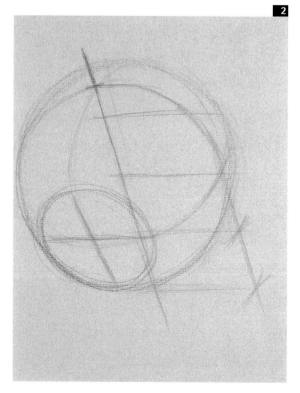

2

3 Then, the basic outlines of the face and its features are drawn, taking care to stay within the previously established proportional divisions.

4 The process continues with the modeling of the volumes. The distribution of light and shadow areas are created with soft tones (sanguine, sepia, white) and black highlights.

5 The contours and shading of the face must be executed carefully and gradually, without darkening or lightening a particular area too much to the point where the balance is compromised. The process may continue until the traditional appearance of this type of drawing is achieved (never too finished, so the entire composition maintains a sense of freshness).

BLOCKING IN LINES
The lines of the diagram may be almost completely erased before the shading process begins. Whether they remain visible or not does not affect the quality of the drawing. The artist must remember that in most of the drawings done by the great masters, traces of the lines used for blocking in the work remained visible.

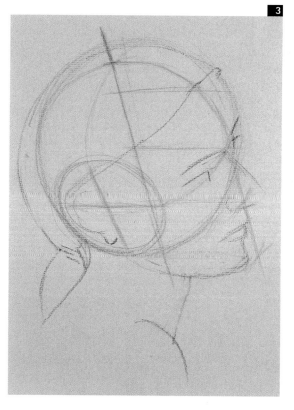

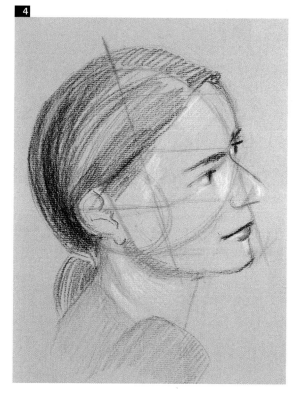

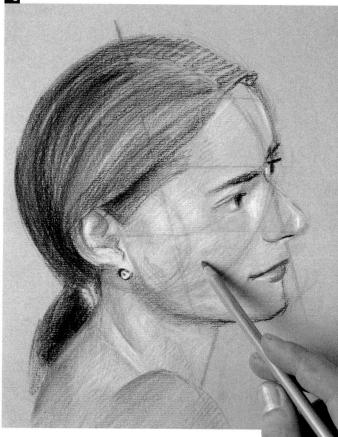

Two Male Heads

The mechanics of how to diagram the head have been sufficiently explained and illustrated so as not to require further detailed analysis of each and every one of the construction stages. The two exercises illustrated on these pages apply the same procedure for two male heads, which as we already know have the same proportions as a woman's head.

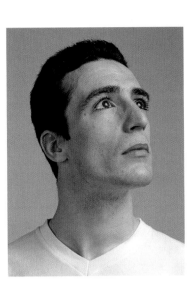

The position of the head is very similar to the woman's head in the first exercise of the series developed in previous pages. In this case also, the head is raised and the eyes are looking up.

MATERIALS
- Colored pencils
- Sepia and sanguine pastel pencils
- Gray paper

1 Here are the nearly completed blocked-in lines with the correct placement of the required tilt and the basic references of the sphere, which include its central point.

2 This picture shows the distribution of the basic references on the front line of the diagram. It is important to notice the reference for the mouth, which occupies the middle of the lower module.

3 By using the proportional references as a guide, the lines of the facial profile and features can be drawn.

4 Finally, the basic volume of the facial anatomy is reinforced and shaded.

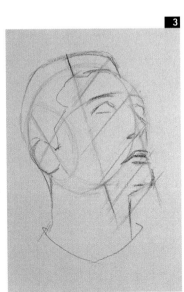

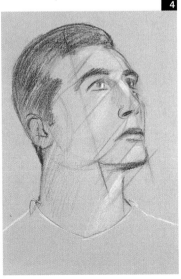

TECHNIQUES USED
- ◆ Proportional divisions of an adult's head ◆
- ◆ Drawing the features ◆
- ◆ Blocking in the head ◆

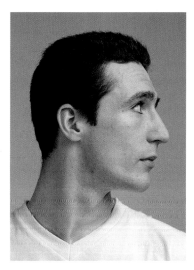

The particular feature of this position of the head is that it is not completely in profile but slightly tilted outward. To draw it correctly, the basic diagram must have the correct (very slight) angle.

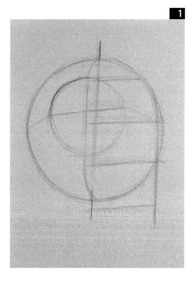

1 Here, we can clearly appreciate that the blocked-in sphere is not placed completely sideways but tilted somewhat backward.

2 Drawing the head proportionately using the references is done exactly the same way as shown in previous exercises. Even though the position of the sphere is less angled than before, the slight perspective effect must be resolved the same way.

3 Finally, all the features are drawn and shaded. If the blocked-in sphere has been drawn correctly, the pose direction of the head must coincide with that of the real model.

FINAL ADJUSTMENTS

The purpose of any method of blocking in is to make a good drawing. It is possible that at the end of the process, the references from the layout may have created some misalignments of the head or face. In these cases, if the position of the head is correct, the necessary corrections can be made as you go without having to redo the entire drawing from the beginning.

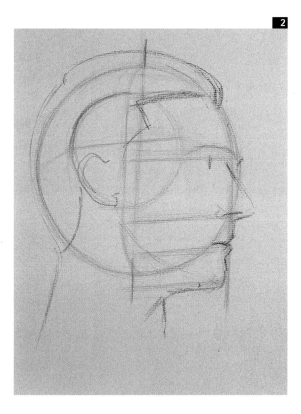

2

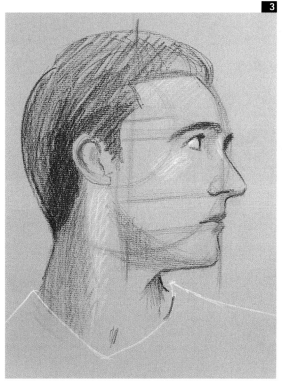

3

Simplified Blocking Methods

The method of blocking in explained and illustrated up to this point is not the only one that can be used. However, finding another one as complete and, at the same time, as simple is difficult. There are nearly as many ways of diagramming the head as there are portrait artists. Most of them are abbreviated methods for establishing the correct positioning of the features and proportions using just a few lines. These two pages and the one that follows cover some of those methods. One way or another, they are all based on the modular division of the head. In general, though, they are more tentative than the ones previously explained, because the artists that use them have great experience and do not need so much preliminary preparation. It is worth paying attention to these methods and practicing them once the artist has become familiar with everything explained so far.

A pose similar to those previously drawn. In this case, it is going to be worked out using a much simpler method that requires a little more practice.

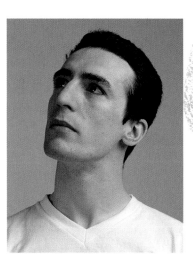

A LAYOUT FOR EACH CASE
Ideally, each model should suggest to the artist the most appropriate layout composition for drawing him or her, more or less elaborate depending on the difficulty of the pose.

Instead of the spherical diagram, a cube is used here. The cube is tilted at an angle similar to the inclination of the model's head, and the proportional partitions are shown on it.

With the required practice in artistic drawing, achieving these results when parting from the previous simple cube diagram is not difficult.

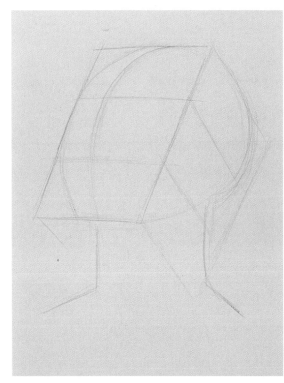

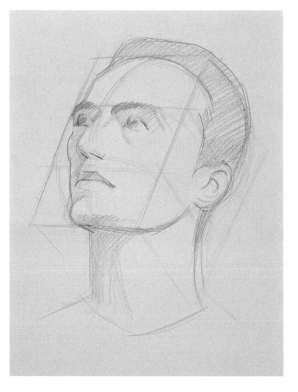

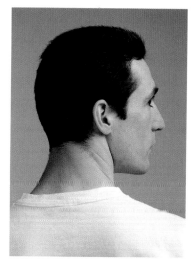

This is a foreshortened head that can almost be resolved as if it were a modified profile. Here the cube diagram becomes a simple square diagram.

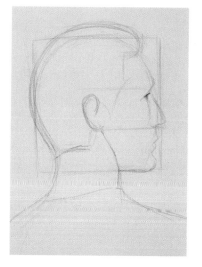

To incorporate the features correctly when parting from such a simple diagram, the artist must have sufficient practice working with the layout explained before. In any case, the position of the head and the foreshortening of the facial features are not difficult to resolve.

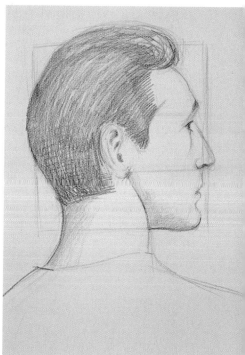

After completing the hair, this simple drawing done very quickly and with a very simple layout can be considered finished.

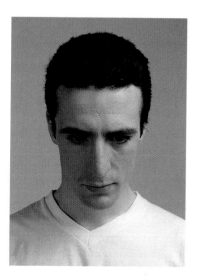

The foreshortening of this head presents some problems of proportion, which can be resolved intuitively using very simple blocking.

A foreshortening that looks hard at first sight can be resolved with a very simple layout. The secret resides in the creation of the correct forms that cover the overall position of the head.

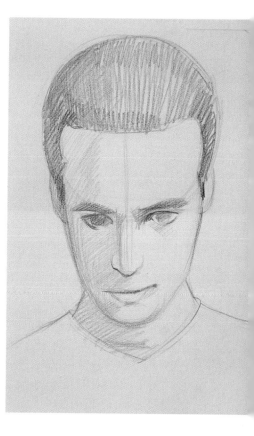

Finally, the hair is shaded, and the lines that define the shape and the placement of the features are darkened.

Foreshortening the Head

On the previous pages, the different foreshortened views have been resolved using several blocking methods. When the foreshortening is very marked, the complicated methods are useless because calculating the proportional partitions is more difficult than drawing the real contours of the head effectively. The most complicated foreshortened poses can be achieved only with practice and experience. Very often, this type of forced perspective is easier to draw than it appears. It is all a matter of observing the model and copying exactly what one sees without paying too much attention to any possible disproportions.

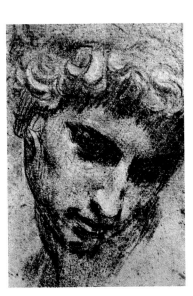

Jacopo Tintoretto, Study of Apollo's Head. Galleria degli Uffizi (Florence, Italy). Painters like Tintoretto were masters of foreshortening. This type of head, seen from high above or way below, is common in his body of work.

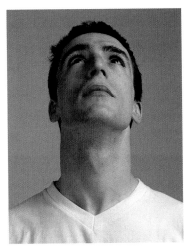

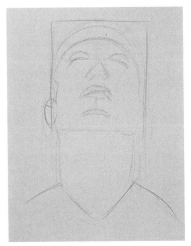

Drawing this foreshortening using the conventional blocking method can be a difficult task because the proportional divisions almost overlap, and the slightest error can result in a considerable disproportion.

To draw this foreshortening, a very easy blocking method is used, a simple square. The divisions do not correspond to the proportional partitions but are used as approximated references for the width of the skull and the placement of the nose and mouth.

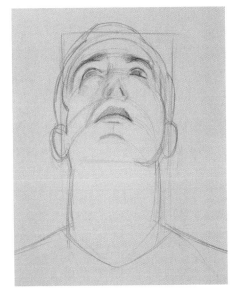

From this point on, it is simply a matter of copying as closely as possible what is seen on the model without paying too much attention to the previous sketch.

This is the result, a drawing that is proportionately correct and that resolves the foreshortening, which appeared to be very complicated.

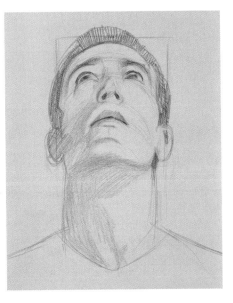

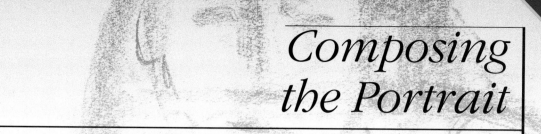

Composing the Portrait

In practice, applying all the techniques shown so far would be sufficient to create an accurate portrait. However, if the artist wishes to create a work of art and not only an example of a technical application, other aspects need to be addressed.

This chapter focuses on the study of the pose, the composition, and the lighting of portraits, with a final section devoted to self portraits. All these considerations make portraiture a true artistic genre and not only a mere copying of facial features. Matters such as the selection of the pose or the lighting are the factors that truly mark the difference in a work of art. An artist must always remember that for the viewer a portrait is the representation of a person through the eyes of the artist, and that the result says as much about the artist as about the person represented. A mechanical approach will reveal the indifference or the inability to reflect the aspects that truly justify the portrait as an artistic form: the expression of the personality.

◆

*Considerations
like the selection
of the pose, the
composition, or the
lighting truly mark the
difference of the quality
of a portrai.*

◆

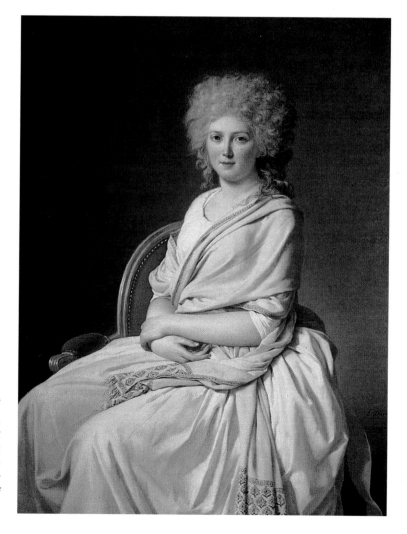

Jacques-Louis David, Portrait of Ana-María-Luisa Thélusson, Countess of Sorcy. *Alte Pinakothek (Munich, Germany). The harmony in the distribution of spaces and the appropriate lighting are key components in the creation of a portrait.*

Choosing the Pose

The selection of the pose for the portrait must never be left to chance if the artist's intention is to create a work of art. The characteristic pose of each person is as significant as his or her tone of voice; it is a defining feature. Therefore, the artist must discover it and emphasize it. Every person has a more meaningful profile and a more revealing attitude, these features are the ones that constitute the pose. Unless the artist knows the subject well and has a precise mental image, the selection of the pose can be a long process that requires making various studies and sketches.

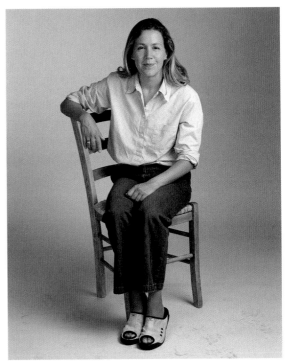

The selection of the pose must stem from an initial idea (seated figure, reclined, standing), which must later be developed through sketches.

After beginning with a specific pose, variations and possibilities are developed.

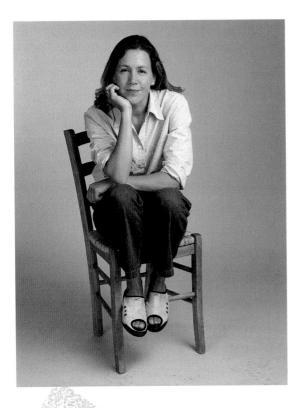

ABOVE ALL, COMFORT
The model must feel comfortable with the chosen pose, so he or she can remain motionless in that position during the session. The clothing must not appear too rigid: the folds and wrinkles always offer a good opportunity for artistic interpretation.

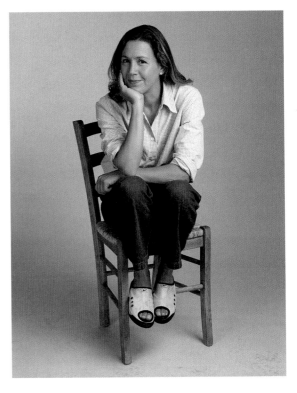

Gradually, the sketches guide the artist to the most appropriate pose for the portrait.

Positioning the Body

For a portrait of just the head, the model should be seated as if it were a half-length portrait. In either case, the model's head should be at the same height as that of the artist. Also, the artist must make sure that the position of the head points in a different direction than the body—this will result in a more gracious and dynamic pose. As with everything in art, this must not be taken as a rule that is written in stone. Many painters, like Modigliani, created most of their portraits with the models in complete frontal positions.

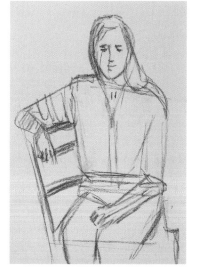

This sketch is a study of a half-body composition with the figure seated facing the front.

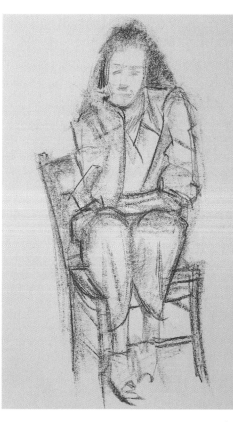

This hunched position allows the artist to attempt a full-length composition.

THE HALF-LENGTH PORTRAIT
The subject of the pose is more complicated in the half-length portrait. With a seated model, consider the possibility of resting the hands in the lap, or on the right thigh or on the left thigh, with the arms more or less bent. You can also try it with the body facing forward and the head slightly turned to one side, or with the body nearly in profile and the head facing forward.

The same position as before but in a half-length variation.

A new version of the half-length from a different pose.

This sketch is a compilation of various sketches and combines the full-length composition with the half-length.

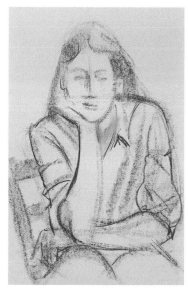

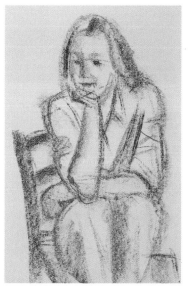

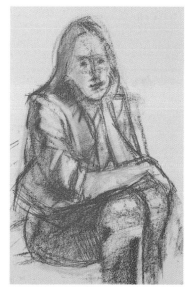

The Relationship Between the Figure and the Background

When a portrait artist makes preliminary sketches for a work, he or she should look for the best way to approach the composition. The overall composition should be a balance of ideal proportions between the model and the background. The figure should not appear too large or too small within the composition, but fit perfectly against the background. The artist will acquire this sense of harmony only through experience and practice, but there are some points that can be learned. For example, too much space should not exist between the head and the top border of the canvas. Also, the lower part of the composition should be occupied by the figure or by any other auxiliary element that enhances or solidifies the overall feeling.

The Problem of Symmetry

Symmetry is synonymous with immobility. The human body is symmetrical. A portrait whose composition is also symmetrical creates a rigidity that must be avoided. To do so, the artist tries to break the symmetry by having the model place his or her hands to the side, by tilting the body away from the head, and so on. The painter can also resort to another basic procedure that is often used by portrait artists. The composition is arranged in such a way that the space between the head and the edge of the canvas is larger in the area toward which the model's head is turned. If the head turns to the right, the space here should be greater than on the left, and vice versa. If the head of the model faces forward, both margins could be equal as long as the pose itself breaks the symmetry of the composition.

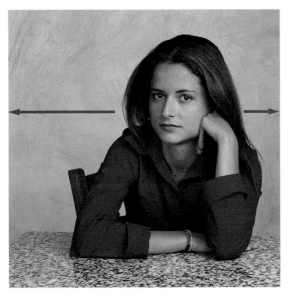

The space in the background should be greater in the side toward which the model's head is facing.

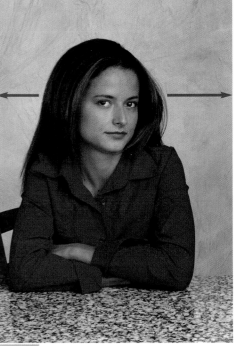

Even when the tilt of the head is very slight, it is important to have more "air," more empty space, in that area.

The space at either side of the head can be approximately the same as long as the pose breaks the symmetry of the composition.

Basic Layout for a Composition

The most common layout for the composition of a portrait is a triangle. This means that the basic shape in which all the elements of the portrait must fit is a triangle. Its top point must coincide with the figure's head and the bottom with the base of the painting. This is the most stable and pleasing composition and the one most frequently used by the classical artists like Raphael. Many great painters have followed this structure, creating such significant variations like the famous off-centered compositions of the Impressionists, and of Degas in particular.

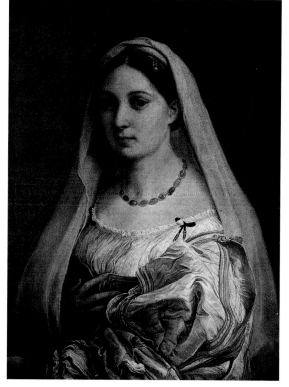

The pyramid-shaped composition, perfectly centered and confined within the format, is the classic layout of choice and the one most frequently used by portrait artists beginning in the Renaissance.

Raphael, Portrait of a Woman Called La Velata. *Palazzo Pitti (Florence, Italy).*

Edgar Degas, Seated Woman. *Musée d'Orsay (Paris, France).*

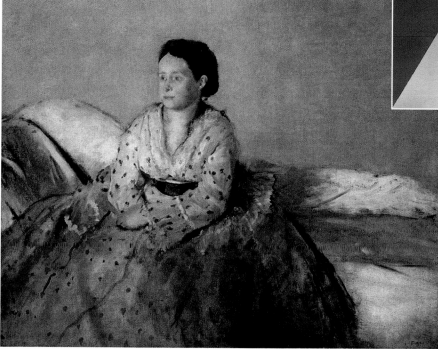

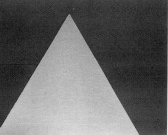

The Impressionist painters and their followers searched for new compositions for their portraits. Among them, this version of the classical triangular layout stands out. It breaks with the traditional symmetry by moving the composition to one side.

The Direction of the Light

In a portrait, the most appropriate direction for the light is from the front and side, understanding that it should be more frontal than lateral. Certainly, the projection of wide and heavy shadows, which unnecessarily complicate the drawing, are not interesting in a portrait. Therefore, the light source should be placed only a little to the side and slightly raised. The nose should project only a nearly vertical shadow. The light should be tilted enough to the side for half of the face to be slightly in shadow, and this side should be closest to the artist. Also, the contrast between the areas in light and shadow should be a little softer in a woman's portrait than in a man's.

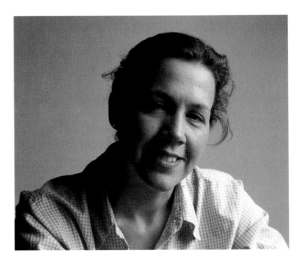

Too much of a contrast between light and shadow excessively highlights the sense of drama.

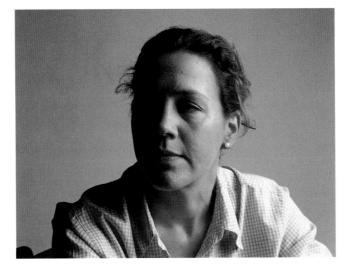

In a feminine portrait, light that comes too much from the side breaks the continuity of the soft surfaces and makes the expression harsher.

In general, portraits of women should be lighted from the front to enhance the softness of the volumes.

NATURAL OR ARTIFICIAL LIGHT

For an artist, the main difference between natural and artificial light is that the former is totally white and does not disturb any colors in addition to being more indirect. Artificial light is much more direct. It also makes controlling the relationship between light and shadow on the model's body and features a lot easier. It is perfect for pencil drawings in which there is no need to capture the color exactly.

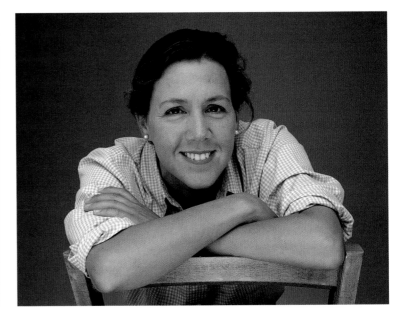

The Lighting

Making preliminary studies or sketches is vital. Through them the artist has the opportunity to analyze the work in depth, to investigate with each sketch the most appropriate position and lighting. Through these preliminary drawings, the artist will have the opportunity to explore his or her creative imagination and to think about the artistic quality of the work, that is, about the composition, the contrast of light and shadow, the execution, and the style.

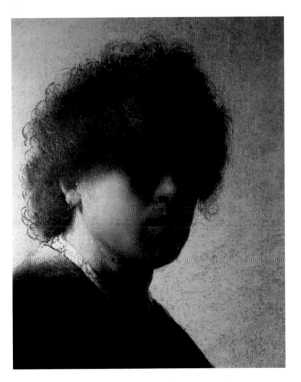

Rembrandt, Self-portrait. Rijksmuseum (Amsterdam, Netherlands). The "special effects" lighting was widely used by baroque painters to create a sense of drama in their work.

In this portrait of a man, the light projected from the side tends to give character and expressiveness to the face.

In specific instances, side lighting may be interesting in highlighting the symmetry of the face.

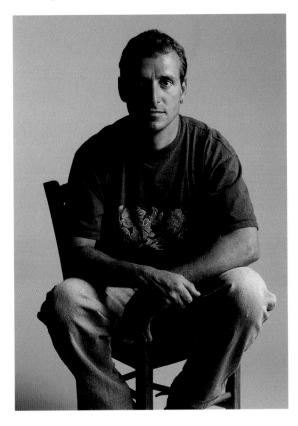

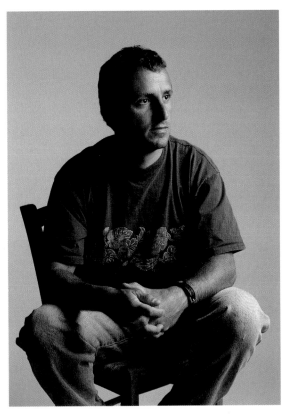

The Self-portrait

The most accessible way to practice all the technical and aesthetic factors that surround the art of portrait making is with the self-portrait. The artist is free to try out whatever he or she wants without having a model sit for long and tedious hours and without having anybody complain about the results. The artist simply needs a mirror and adequate lighting. However, the freedom of the artist may be compromised by respect for his or her own facial appearance, and then the exercise turns into a simple pastime. In the different versions of self-portraits illustrated on this page, the correct attitude is presented: an attitude of discovery and experimentation, which has nothing to do with the search for the most appealing angle to fulfill personal vanity.

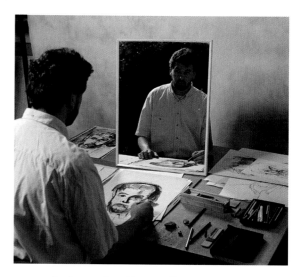

A mirror and a table, as well as adequate lighting, are the only requirements for practicing the self-portrait.

This is the result of a practice self-portrait: a possibility for expression and working on techniques, among many other things.

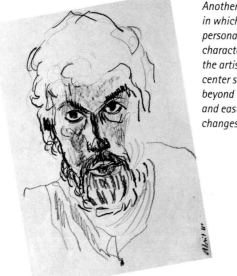

Another sketch in which the personal character of the artist takes center stage beyond technical and easthetic changes.

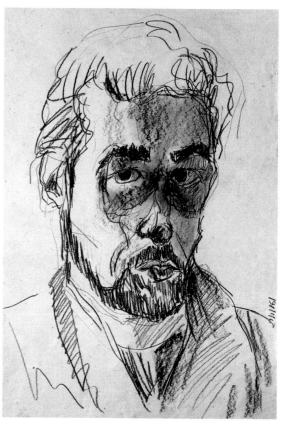

The expression, the technique, and part of the physiognomy have changed, but the personality is represented the same way.

The Practice of Making Portraits

The last pages of this book are devoted to the practice of portrait making in all mediums. A series of processes are presented that summarize the developments used by the majority of portrait artists.

This last section is devoted to the real practice of portrait making as it is understood by most professionals. The reader will find all the subjects covered in the book applied in the elaboration of a series of projects that go from portraits of infants to full-body portraits and various examples of heads, busts, and half-body compositions. Another interesting aspect of this chapter is the use of different artistic procedures, from sanguine to oil painting and watercolor to pastel. Each one of these mediums requires an adjustment of the basic techniques for the layout and execution of heads and portraits. However, the techniques themselves are the same for any medium chosen.

◆

Each of the exercises in this chapter requires an adjustment of the basic layout techniques for the creation of heads and portraits.

◆

All the works are explained step-by-step, from the initial layout to the final touches, so the reader can verify at any given time the resources used in each case. These exercises at the professional level show the real use of all the partial techniques studied in this book.

These are two results achieved by following the processes covered in the following pages.

Study of a Man's Head

This is the first in a series of three exercises in which a head is drawn by applying the blocking methods and calculating proportions as presented on the previous pages. This head of a man exactly fits the canon of dimensions, maintaining the same relationship between the width of the forehead, between the eyebrows and the base of the nose, and between the latter and the chin.

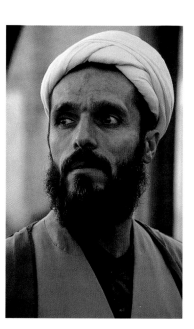

This head has very defined features and clearly reveals the bone structure under the skin. This helps establish the basic references for the drawing.

MATERIALS
- Light sienna Canson paper
- Colored pencils: gray, raw sienna, and burnt sienna

1 The oval for the head should be drawn according to the point of view from which it is taken: slightly low and tilted to the right with respect to the frontal plane of the face.

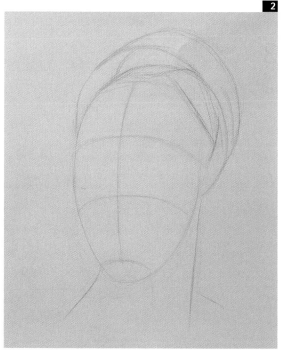

2

2 The basic points of reference of the symmetry axis, the eyebrows, and the nose are placed according to the canon of proportions. Also, the shape and position of the turban has to be indicated.

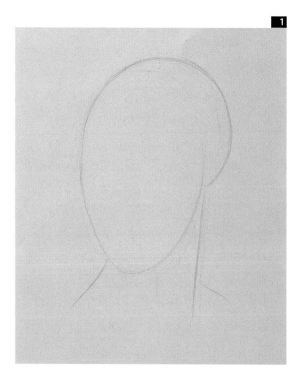

1

TECHNIQUES USED
◆ Blocking in a man's head ◆
◆ Proportions of the features ◆

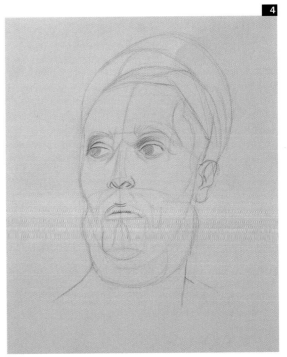

3 The accuracy of the previous references is evidenced at the time of drawing the features. The previous layout of the proportions results in a correct composition and resemblance with the model.

4 Only after properly laying out the shape and placement of the features, and if there are no mistakes in the proportions that are particularly visible, the artist may begin to draw the details in each area of the face.

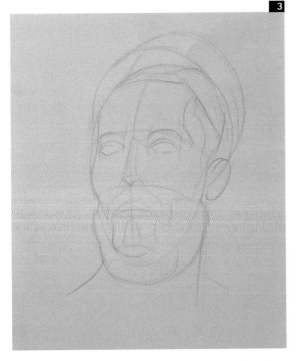

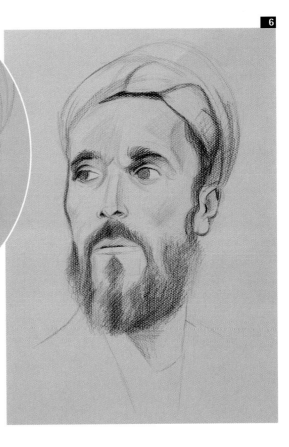

5 The shading and shaping of the beard must be done by darkening the tone gradually, without attempting to achieve the proper shade from the beginning. The blocking lines are a great help for guiding the work at this phase of the project.

6 To finish the drawing, a contrast must be created between the darkest areas of the beard and the hair. The volumes created by the prominent bone structure of the model's face must also be softly contoured.

Study of a Woman's Head

The head of a woman usually does not have as many bone structure references as the head of a man. This is why the artist must be careful when blocking in the figure and calculating the optimum proportions of the features, so a likeness can be achieved. The process for this drawing is the same as for the previous exercise. It focuses on the volumes of the head without making excessive use of shading.

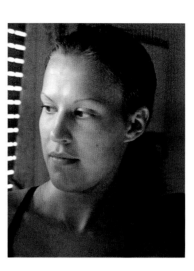

The position and the tilt of the head introduce elements of difficulty in a drawing, which basically consist of arranging the features in a well-proportioned whole.

MATERIALS
- Light sienna Canson paper
- Colored pencils: gray, raw sienna, and burnt sienna

TECHNIQUES USED

♦ Blocking in a woman's head ♦
♦ Proportions of the features ♦

1 The general oval with its dividing lines is always the first step in laying out the head. The proportions are the same as for a man's head.

2 The shape of each facial feature is drawn over the reference lines, trying to be as faithful as possible to the characteristics of the model.

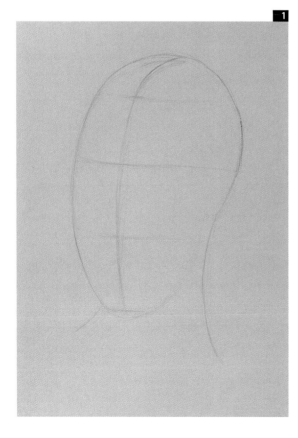

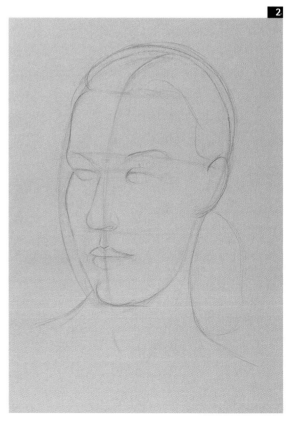

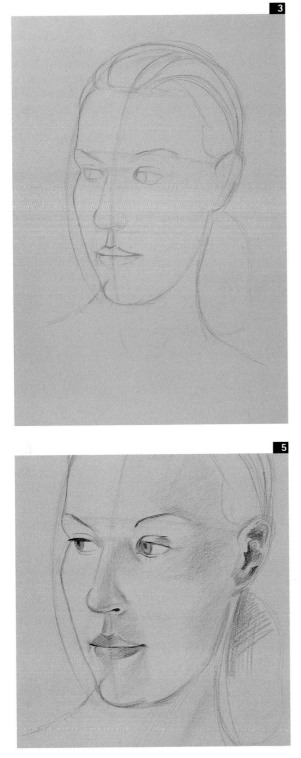

3 The drawing continues to be enhanced with new details, which reinforce the resemblance to the model.

4 Slight shading of the facial features provides vitality and expression to the overall drawing.

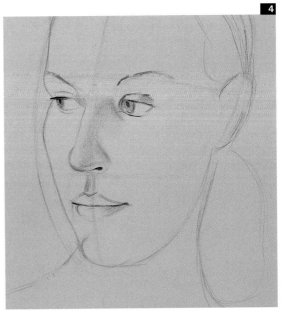

5 The overall shading should be applied softly and gradually so the shaping of each particular area is integrated in the composition.

6 This is the result of methodically applying the construction process to the face.

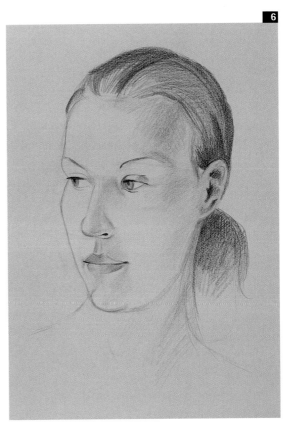

Study of a Child's Head

This is the last head study exercise. It consists of a child's head seen in profile. In addition to the differences in proportions, this drawing has other peculiarities, like its view, which is completely in profile, and its blocking, done using a square shape. Other than that, there are no significant variations from the typical process for drawing the human figure.

MATERIALS
- Light sienna Canson paper
- Colored pencils: gray, raw sienna, and burnt sienna

The view of this girl's head is completely in profile. This can make certain aspects of the drawing easier because a single outline can provide all the information required to achieve the likeness.

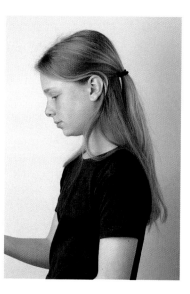

TECHNIQUES USED
- ◆ Blocking in a child's head ◆
- ◆ Proportions of the features ◆

1 Preliminary blocking of the drawing. This blocking has been done using a square shape, which provides the proportions for the height and width.

2 The basic reference lines are added to the preliminary blocking, including the shape of the hair.

3 Little by little, all the facial features should be incorporated in the general layout of this head.

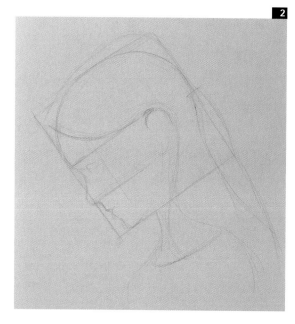

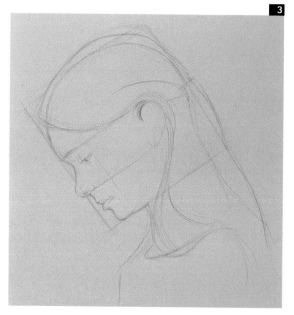

4 The important details must be drawn over so they stand out against the overall drawing.

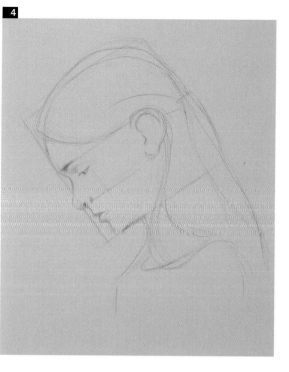

5 When the likeness of the model has been achieved, the hair is drawn softly and with long strokes, which must gradually increase in intensity.

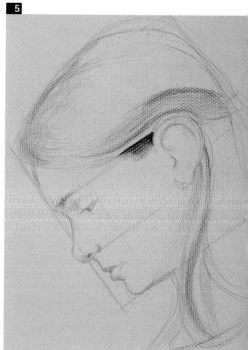

6 Now the blocking lines that have been used during the first phase of the drawing can be erased.

7 This is the final result, a completely accurate work concerning the proportions, resemblance, line treatment, and lights and shadows.

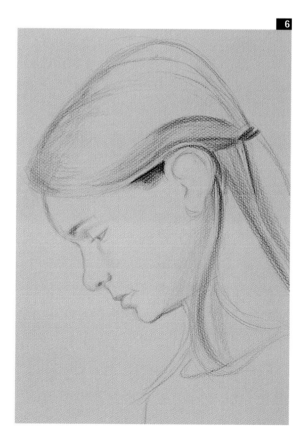

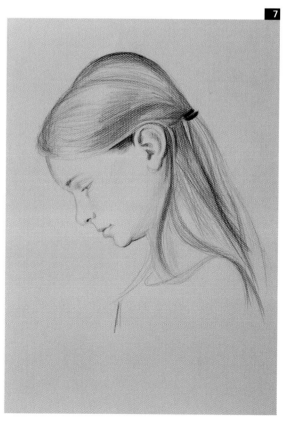

Child's Portrait with Pastels

Children's portraits are to some degree easier to resolve than adults' portraits. The features are more generalized and the facial expression does not have a definite personality yet. The basic problems are well-known: children cannot hold still and drawing them or painting them from a pose is almost impossible. A good photograph, chosen from a selection of studio poses, is the ideal solution.

When making children's portraits, especially if they are very young, the use of a photograph is almost inevitable. This example includes all the necessary conditions to create a good portrait.

MATERIALS
- Pale ochre paper
- Sticks of hard pastels: dark amber, sanguine, English red, cadmium red, yellow, light blue, pink, light pink, white, and black

TECHNIQUES USED

- ◆ Blocking in an infant's features ◆
- ◆ Shading ◆
- ◆ Expression ◆
- ◆ Flesh tones ◆

1 The full frontal position of the model allows the artist to draw the oval outline of the head without taking into consideration any foreshortening.

2 The two main axes for the placement of the features are the line of symmetry (vertical line) and the line that marks the height of the eyebrows, located lower than what is customary for an adult.

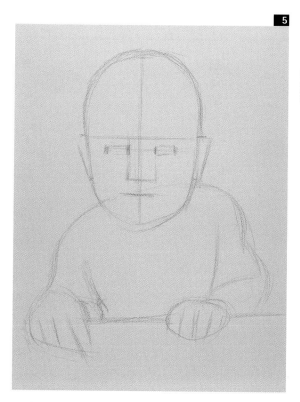

3 These two references correspond to the location of the base of the nose and the mouth. Both are much closer together and closer to the chin than in an adult's face.

4 The distance between the eyes of a child is somewhat greater than the distance that separates the eyes of an adult, that is, more than the width of one eye. The placement of the ears has also been indicated in the drawing.

THE PROPORTIONS OF AN INFANT
If you can calculate the correct proportions of an infant's head, the task of creating the resemblance is a lot easier than in the case of an adult. This is because the face of an infant has fewer distinctive features than that of an adult.

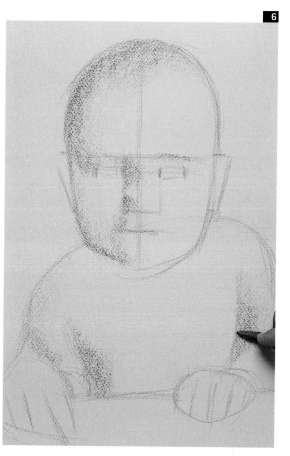

5 The location of the features is indicated on the axis according to the characteristic proportions of an infant's head. When drawing the rest of the body, the artist must pay attention to its size in relation to the size of the head, whose proportion is almost double that of an adult.

6 Once the adjustments to the general proportions have been made and the location of the facial features are correct, the artist can begin shading the drawing.

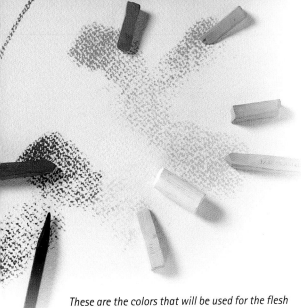

These are the colors that will be used for the flesh tones. As expected, the warm colors dominate: earth reds, yellows, and pinks.

SHADING THE FLESH TONES

When the shading of the skin is done with a wide variety of colors, the artist should begin with a general tone halfway between the lightest and darkest areas. The lightest tones of the skin of the infant in this portrait are very light pink, and the darkest shading is represented with a natural amber color. The logical approach is to use a burnt sienna or a sanguine color as a general base shading, spreading it over the body to create a good chromatic ground base. A few white areas should be applied over this for the general tone to acquire volume.

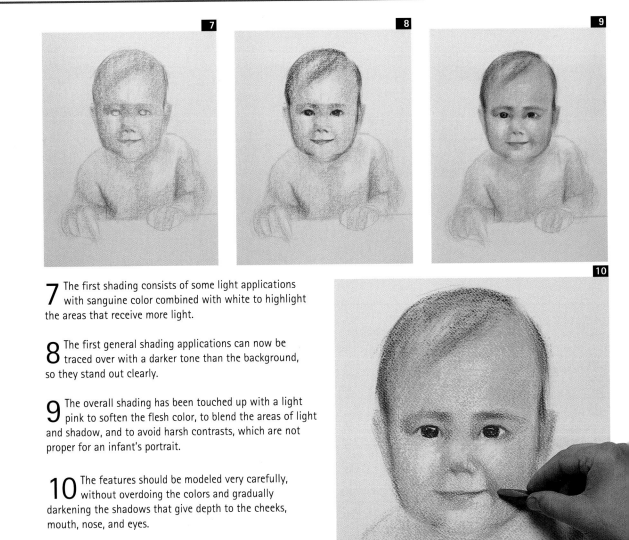

7 The first shading consists of some light applications with sanguine color combined with white to highlight the areas that receive more light.

8 The first general shading applications can now be traced over with a darker tone than the background, so they stand out clearly.

9 The overall shading has been touched up with a light pink to soften the flesh color, to blend the areas of light and shadow, and to avoid harsh contrasts, which are not proper for an infant's portrait.

10 The features should be modeled very carefully, without overdoing the colors and gradually darkening the shadows that give depth to the cheeks, mouth, nose, and eyes.

11 The newly applied shading to the face should be blended to soften the transitions between the areas of light and shadow.

12 Large areas of light pink color have been applied again to tie together the flesh tones and to lighten them.

13 In this phase of the process, the portrait of the child is almost finished. The only thing left to do is to color around the figure and to add a few final details.

14 The artist should not spend too much time adding details or coloring the surface where the child is resting his hands. A light shade of red is enough to do the job for this portrait.

THE SOFTNESS OF THE MODELING
On children's portraits, it is essential to avoid sudden transitions between areas of light and shadow. Forms should be rounded and continuous. Blending one color with the next is therefore very important, and the transition between one and the other must be smooth.

WARM AND COOL COLORS
Darkening the background to make the portrait stand out against it is not necessary. Shading the background with a cool tone (in this case blue) is enough. The contrast between the very warm tones of the child's skin and the cool background is enough to make the portrait stand out.

15 To make the body of the child stand out against the paper's background, light blue is applied around the outside of the contours.

16 Finally some details have been added to the hair, very fine lines of various tones that represent the softness of a child's hair very appropriately.

Bust of a Woman with Oils

The composition of this portrait is a variation of the classic bust. It is a modernized variation because the classic bust always had a wide empty space above the figure's head. The lack of space between the head and the top border of the painting makes the piece very dynamic and the composition less serious. The head is turned to the left of the painting, and it forces the artist to calculate the relative placement of the facial features carefully.

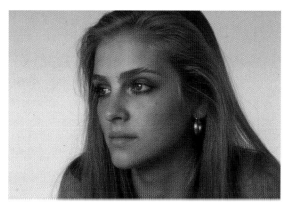

The model is not looking toward the viewer, so the portrait maintains a certain psychological distance. Also, the angle of the head forces the artist to calculate the position of the features carefully.

MATERIALS

- Oil paints: titanium white, lemon yellow, yellow ochre, raw sienna, burnt sienna, vermilion, cadmium red, and ultramarine blue
- Brushes: one medium flat brush and two round-bristle brushes, one medium and one small
- Canvas stretched over a frame

TECHNIQUES USED

◆ Blocking in feminine features ◆
◆ Shading ◆
◆ Expression ◆
◆ Flesh tones ◆

1 In portrait making, the artist can block in the head directly with color, without using preliminary pencil lines. The brush is used here as a pencil or as a pastel stick. Its lines mark the basic references of the head, face, and hair.

2 The locations of the features are marked on the reference lines, paying special attention to the distances between them so their placement looks consistent with the angle of the head.

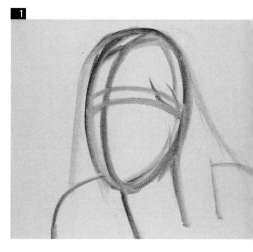

3 The area of the face is isolated from the rest of the head by shading the hair with the same color used for the initial drawing (burnt sienna).

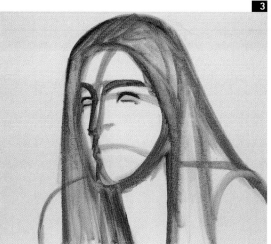

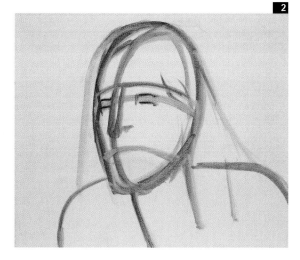

4 The facial features are drawn with utmost precision using the finest brush after their placement on the face has been clearly located.

5 The colors for the tones of the flesh of the portrait are vermilion, cadmium red, yellow ochre, raw sienna, burnt sienna, and white.

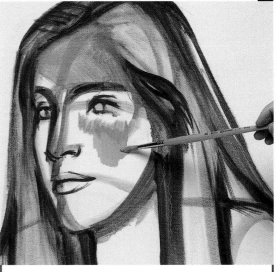

5

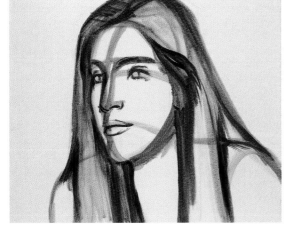

4

6 The initial tone of the skin is an earthy pink that is obtained by mixing raw sienna with a little bit of white and ochre. This mixture must be applied quite diluted to make the color spread evenly over the canvas.

7 During the first application of shades, the basic colors have been blended using touches of burnt sienna, ochre, and white, which are the ones that create a preliminary general modeling of the face.

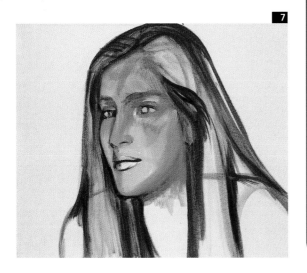

7

6

FLESH TONES WITH OILS
Independently of the colors chosen to paint the flesh, when working with oils, the tones have to be alternated so that the brush stroke of each color blends lightly with the previous one. The fact that oils take a long time to dry forces the artist to begin covering the canvas with thin paint. As new colors and shades are added, thicker paint can be used so the canvas is properly covered without excessive mixing of the colors.

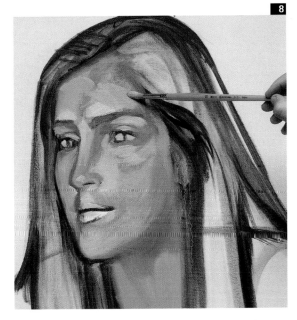

8 Depending on how the tones of the flesh look, some more red or ochre can be added to the mixtures. In this example, the area of the forehead is touched up with light pink.

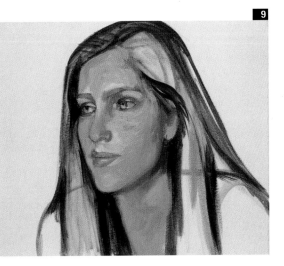

THE COLOR OF THE HAIR
No matter the color of the model's hair, the artist should avoid making the hair look like a wig. To create the appropriate natural look, the color of the hair must be made to look like the color of some areas of the face (the forehead, chin, temples, and so on), blending both colors if needed.

9 The phase of coloring the flesh is in the advanced stages. The face is much more defined, and the color of the skin is much more natural now than in previous stages.

10 It is time to color the hair. The first step consists of spreading a neutral overall tone: a light greenish gray that goes very well with the blond highlights of the strands of hair.

11 The overall tone of the hair has several areas of shadows, which are the ones that give body to it. The greenish tone suggests a golden color.

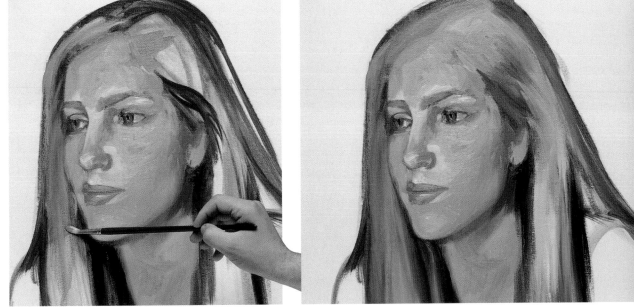

73

HIGHLIGHTS AND REFLECTIONS

It is a very common mistake to paint blonde hair with only ochre and yellow tones. The conventional idea of associating the color gold with yellow should be abandoned immediately because the result is an effect that is not very natural. The gold tones have greenish hues. Among them, yellow can stand out as a highlight but not as a basic color. Another common mistake is to highlight the light areas of the face excessively, to the point where they end up looking glossy. This must be avoided by reducing to a minimum the applications of pure white over the flesh tones.

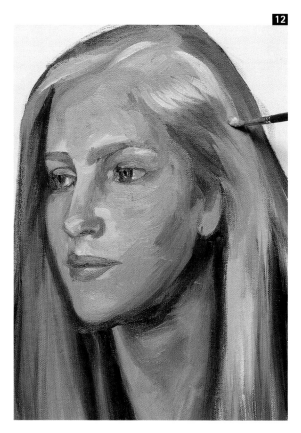

12 Very light brush strokes are added over the base of greenish color to represent the highlights of the hair. The direction and the shape of the brush strokes are very important at this point because the waves of the hair depend on them.

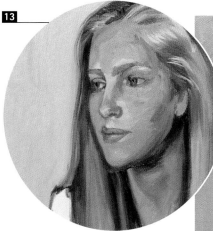

13 The light blue tone of the background helps highlight the warm values and shadows that shape the face and the hair of the figure.

14 The final touches to the skin tones consist of softening the paint on the cheeks by spreading the color and by blending it with the neighboring colors.

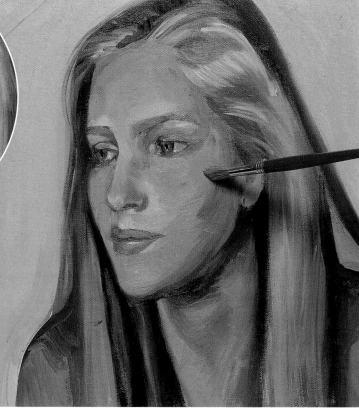

THE GAZE

The expression of the gaze does not depend as much on how the eyes are drawn as on the values of light and shadows and especially on the highlights on the eyeball. These highlights must always be placed just to the side of the black area of the pupil.

15 All the work related to painting the skin and the hair is finished. The only thing left to do is to touch up the eyes with a few highlights that create a lively expression.

16 The details of the highlights and the pupils of the eyes have greatly enlivened the expression, which before appeared absent. After these small applications of color, the portrait is considered finished.

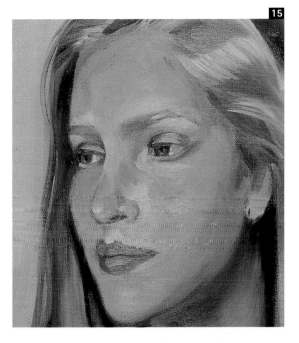

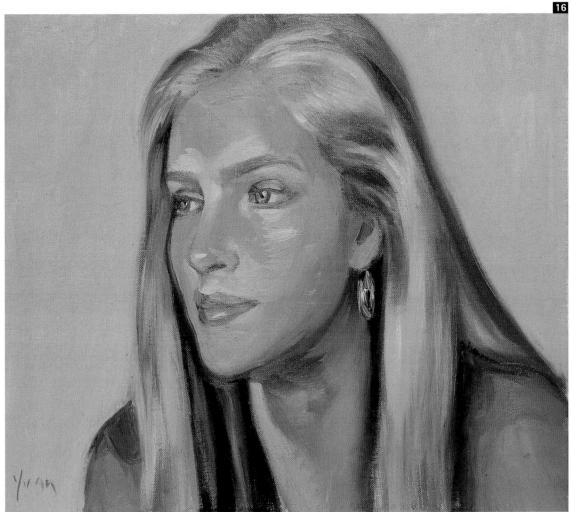

Shading in Portraits

After reviewing the appropriate techniques for drawing a human head and for a portrait in general, the next step toward a true artistic achievement of the portrait is the application of shading. Shading consists of playing with different tonal intensities, lighter or darker, to give the portrait volume and artistic quality, even without applying color. This exercise is done in monochromatic tones, using a sanguine color made lighter with white and darker with black in specific areas.

The pose chosen for the portrait is not going to be represented in its entirety. The composition will focus on the upper half to create a more compacted look.

MATERIALS
- Creme-colored Canson paper
- Stick of sanguine
- Stick of white chalk
- Sepia pastel pencil
- Charcoal pencil
- Wide, flat-bristle brush
- Eraser

1 When the most appropriate composition for the exercise has been chosen, the figure is sketched out. By applying the entire length of the sanguine stick on the paper, straight lines can be drawn quickly.

TECHNIQUES USED
- ◆ Blocking in the head ◆
- ◆ Composition of the pose ◆
- ◆ Shading ◆

2 The corrections to the drawing are made as the artist progresses, making the lines fit the model's form without taking into account the outline and looking for references in each area of the composition.

3 After the lines have been completed, the bristle brush is used to blend the lines and to create the first overall approach to the shading of the figure.

1

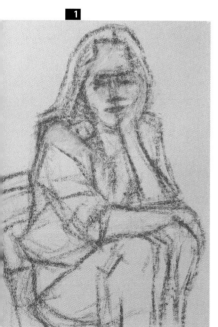

2

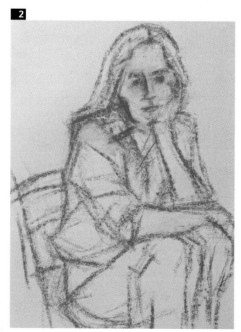

3

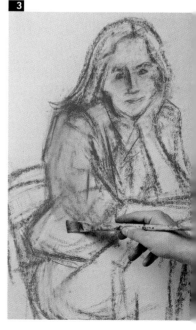

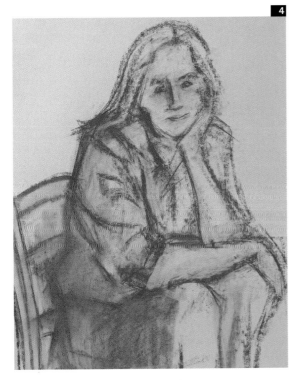

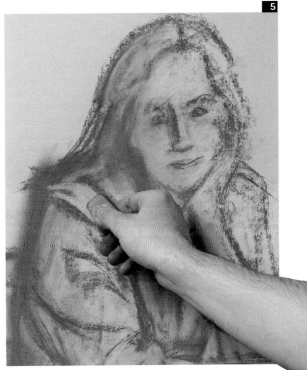

4 Here is how the drawing looks after the sanguine lines have been blended with the brush. Note that the darkness of the blended area is due to the successive applications of sanguine during the work with the brush.

5 The paper has been covered with sanguine color. Restoring its original color is possible with an eraser. Using it will create quite a wide range of lights and shadows, which will represent the first step in the shading of the work.

6 This picture shows how shading the sleeve of the blouse has turned it into an energetic expression of volume.

7 Shading consists of adjusting certain areas of the drawing with the rest. This means that each adjustment results in an overall modification: light and shadows modify the drawing, and they, in turn, modify the shading.

TOUCHING UP THE DRAWING AND THE SHADED AREAS

This exercise reflects many changes in the drawing of the model. This is not uncommon. The likeness, as well as the rest of the important factors of the portrait, can be created as much by continuous efforts of trial and error as by the layout of an initial definite drawing.

WHITE HIGHLIGHTS

In a monochromatic drawing, the use of white highlights (white chalk or pastel in this particular case) provides richness to the composition by adding lighter tones that could not be otherwise obtained with monochromatic colors. Obviously, for these highlights to be effective, using a colored drawing paper as a base is necessary, because there is no lighter shade than the white of the paper itself. White highlights are common in drawings done in charcoal or sanguine.

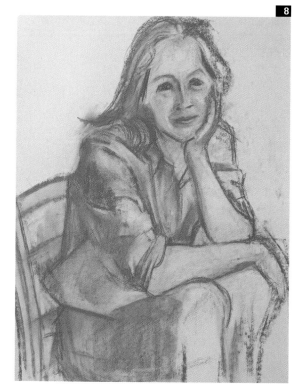

8 Before engaging in detailed shading, the artist must confirm that the overall drawing is well composed and that no changes need to be made to any part of it.

9 The highlights with white chalk are applied with a piece of chalk placed completely flat on the paper to create a white area that will be blended later.

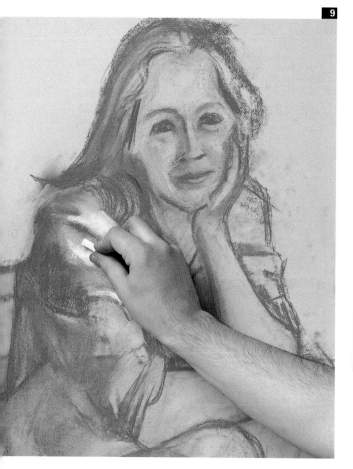

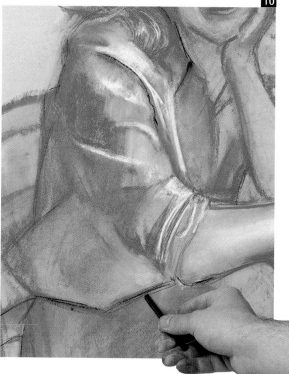

10 The white highlights can be enhanced later by adding shadows with a black pastel pencil, for example, at the lower edge of the blouse's fold, to make it stand out against the pants.

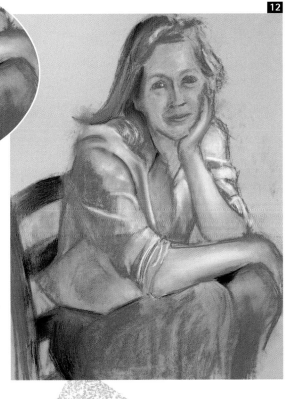

11 The strong darkening of the pants has solidified the overall composition by introducing a shade that is much more somber than the rest of the drawing. The purpose of this is to focus the theme of the work on the torso of the figure.

12 The white highlights also play a role on the arms. They have been generously shaded with white chalk and later blended. The absence of sanguine lines in this area makes the volume of the arms stand out clearly.

13 The face has to be worked very carefully so the shading does not alter the features. The artist should use sanguine, white, and sepia pencils instead of sticks.

14 Pastel pencils provide much more precision than the sticks. They can also be used for shading as well as for drawing well-defined lines.

PENCILS AND STICKS
All the common colors of chalk (sanguine, sepia, white, and black) can also be purchased in pencil form. The point of those pencils is manufactured of the same material as the sticks. The advantage of pencils is that they can be used for the smaller details and for drawing the outlines that have been rubbed off.

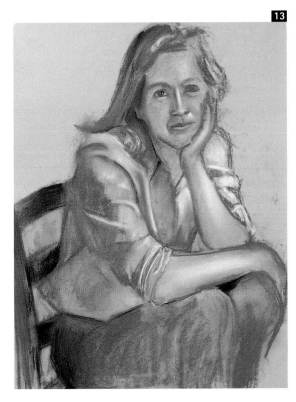

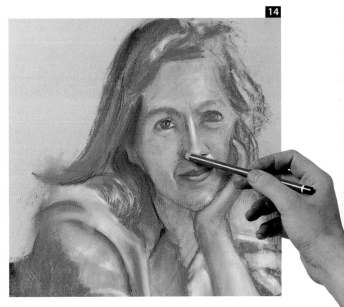

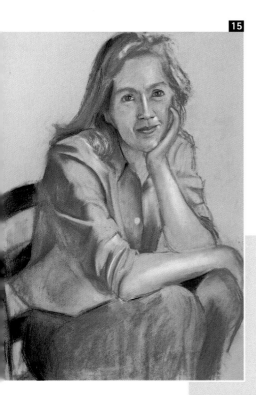

15

FINISHING

This type of drawing can be touched up and detailed as much as one wants. Not overworking the finish is better, though, because it can end up having too much detail and shading. Leaving some areas with a sketchy look in contrast with others that are more finished is a good idea.

16

15 The facial features, the last step of the entire shading process, are completely finished. The only thing left to do is to define some marginal areas for the work to acquire its full potential.

16 A last darkening of the pants of the model and a better defining of the lines and the areas of color that shape the chair are the applications that complete this shading exercise.

Bust of a Man with Oils

The following portrait conforms to the classic compositional rules: slightly off center, with empty space above the head, and clearly contrasting against the background. This will be created with the most traditional of the mediums, oil paints, putting into practice all the rules we have studied about composition, resemblance, expression, and flesh tones.

A slightly lateral light source projects enough shadows to make the volumes of the face clearly stand out.

The composition of the photograph has been arranged to conform to the classic composition of a bust. The light has been chosen to define the facial features clearly.

MATERIALS

- Canvas panel
- Soft-lead pencil
- Oil paints: cadmium yellow, yellow ochre, cadmium red, burnt sienna, carmine, permanent green, ultramarine blue, cobalt violet, white, ivory black, and titanium white
- Small and medium round-bristle brushes, large flat-bristle brush

1 With a soft graphite pencil, the overall contour of the bust is drawn and the facial features are outlined, carefully forming the proportions of the head.

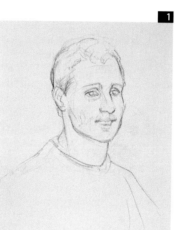

2 The modeling and skin tones of the head are created using a mixture of burnt sienna, ochre, and carmine in different proportions according to the lighter and darker tones.

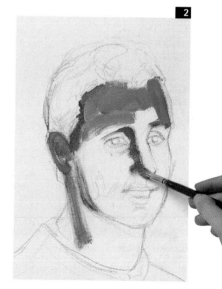

3 The shadows are darker red due to the stronger presence of carmine in the mixture. The structure of the head must be worked on with much care, carefully respecting the likeness established in the initial drawing.

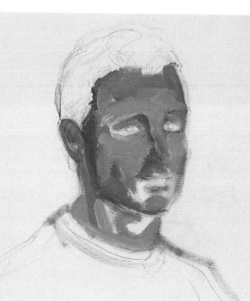

TECHNIQUES USED

- ◆ Blocking in male features ◆
- ◆ Composition of a bust ◆
- ◆ Shading ◆
- ◆ Expression ◆
- ◆ Flesh tones ◆

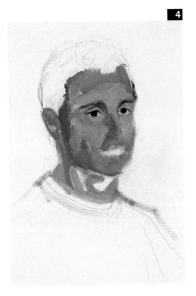

ACHIEVING THE LIKENESS

In this exercise, the likeness has been established from the beginning, in the initial drawing. This task must be carried out with color but without compromising what was achieved in the drawing. The thin brushes used for this phase make it possible to define the shadows correctly and to highlight all the details indicated in the pencil drawing.

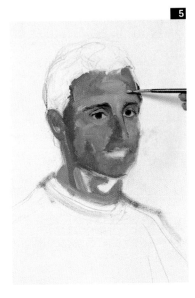

4 The areas of the eyes are defined with a thin brush. This phase is very important to establish the portrait's likeness and expression.

6 The head's color is at an advanced stage, and the coloration of the flesh appears in its natural tones. Only a few small areas need to be resolved.

5 The skin color is worked out gradually, respecting the overall shading scheme, that is, the basic relationship between areas of light and shadow.

7 Applying some cool tones to the warm overall skin coloration is important to highlight the volume and to create the appropriate contrasts. Some green tones can be seen under the lower lip, which represent the shadow of the beard.

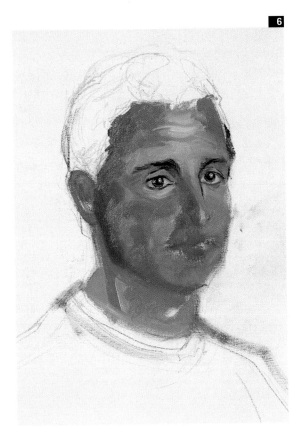

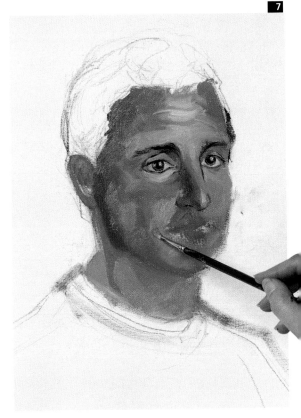

8 The lower lip is one of the few areas that remain to be painted. Its tone has to be lighter than the upper lip since it gets more light than the former.

9 The face is completely finished, and only the hair remains to be painted to complete the head of the person being portrayed.

10 Before proceeding with the model's hair, the background is painted with a light grayish green. This is a cool tone that will create good contrast against the warm color of the skin.

11 The multiple contrasts between the light, the cool background, the dark hair, and the reddish flesh tones add vitality to the portrait.

12 The overall effect of the head against the green background is very pleasing, and it should be maintained.

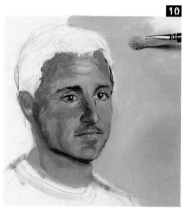
8

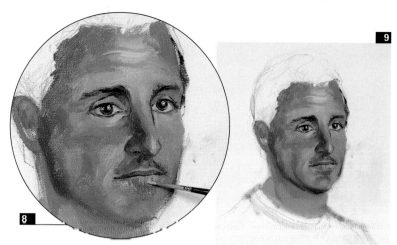
9

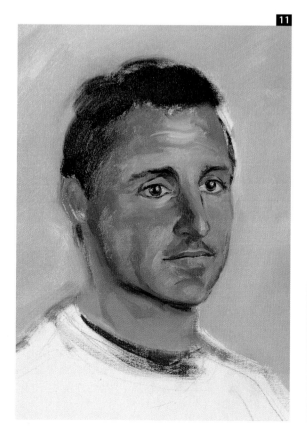
10, 11

CONTRASTS
The likeness and the expression are vital factors in a portrait. The drawing and the color are not the only paths to their success. The skillful distribution of contrasts that enliven the colors, which add vitality to the work, is also very important.

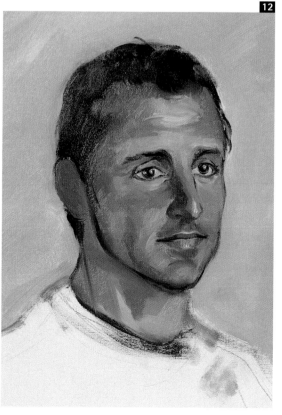
12

THE FINISH
In this work, the finish consists of creating the model's clothing. This is a new opportunity for the artist to add contrasts to give the project more energy without compromising what has been achieved so far in terms of likeness, composition, and expression.

13

13 The blue tone of the model's T-shirt can be substituted with a violet color tinted with white and black. Copying the pattern of the T-shirt is not necessary. In fact, not introducing it at all is better so as to avoid distracting the eye from the subject.

14

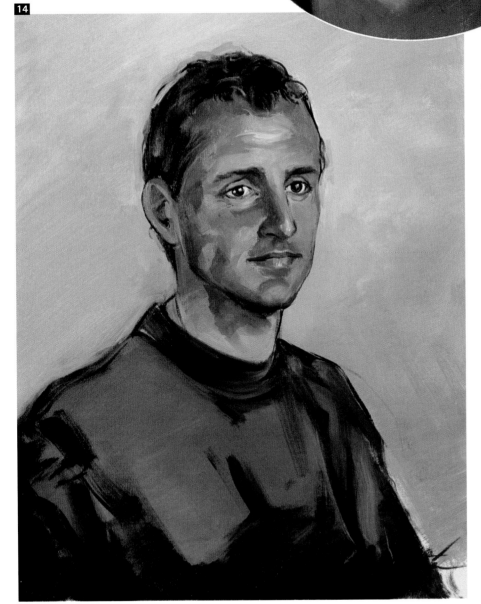

14 The project is completed when all the areas of the clothing have been painted and the folds have been sufficiently defined without overdoing them.

Full-length Portrait of a Woman

The full-length composition is the least common in portrait making. This does not mean that it is not one of the most suggestive possibilities for the artist who is interested in searching for the keys to this genre. A full-length portrait requires using a medium or large support somewhat narrow and long to avoid excessive empty spaces on the sides. For this exercise, a collected and perfectly vertical pose has been chosen.

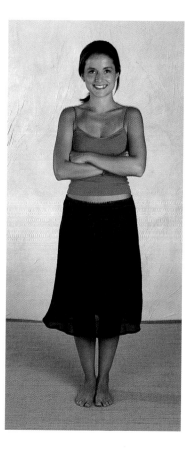

The extended pose with the arms folded in front of the body is completely vertical and presents the challenge of being a totally symmetrical composition. Also, the full frontal pose of the figure lends an even more static appearance that evokes ancient statues.

MATERIALS
- Acrylic paints: lemon yellow, yellow ochre, cadmium red, magenta, burnt sienna, raw sienna, ultramarine blue, violet, white, and black
- White paper
- Two medium round brushes of synthetic hair and one fine round synthetic brush

TECHNIQUES USED
- ◆ Composition of a full-length portrait ◆
- ◆ Blocking in the head ◆
- ◆ Shading ◆
- ◆ Flesh tones ◆
- ◆ Expression ◆

1

2

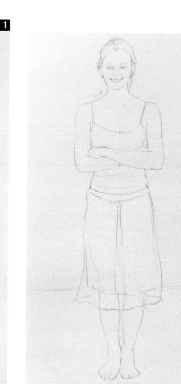

1 The aim of the preliminary drawing is to center the figure within the composition and to check the proportions carefully to make sure they are consistent with the format of the work.

2 When the figure has been blocked on paper, the artist may begin to draw the details of the clothing and the features, paying special attention to the model's smiling expression.

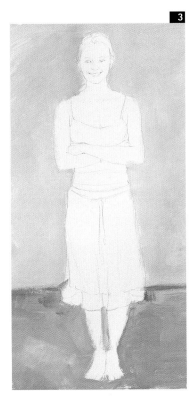

3 When the initial drawing is completed, the background is painted, both the floor and the wall. The colors of the background will play an important role by adding harmony to the overall composition.

4 The first brush strokes on the figure will be the colors of the skin. The initial color for the flesh is a burnt sienna mixed with a little bit of ochre and white. This mixture is used to paint the model's shoulders and the upper chest.

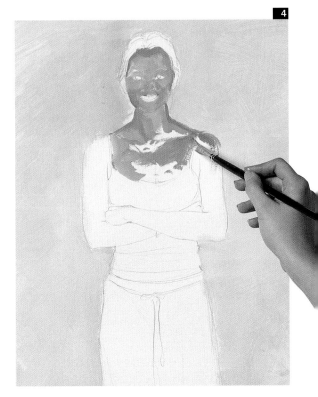

5 From the beginning, the areas of the skin are covered with a first layer of flesh tones that will be worked on later.

6 The color of the shirt is a mixture of magenta with a little bit of white. This color must be a pristine and intense note in the composition of this work, without any distractions due to chiaroscuro or modeling.

HOW ACRYLIC PAINTS DRY
Acrylic paints have a consistency and density that is very similar to oils, but they dry much faster. This circumstance conditions the working method. While the artist can temporarily abandon unfinished areas of an oil painting to work on other areas, acrylic paints need to be finished before moving on to other parts of the painting. The way to correct mistakes on acrylic paintings is to cover them over and repaint them.

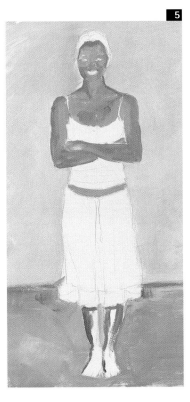

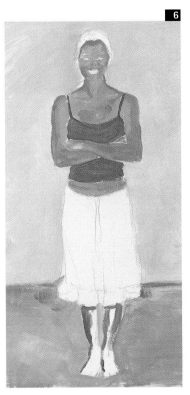

7 The skirt is painted with a violet color without the use of white for the lighter areas. In those areas, the color is applied more diluted with water, while the paint is spread thicker in dark areas to create the darker tone.

8 The main colors of the painting have now been applied to the paper. They consist of multiple contrasting colors in which each part presents a characteristic coloration.

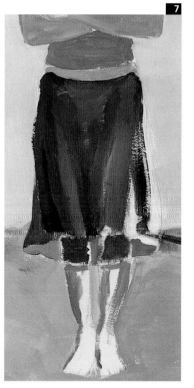

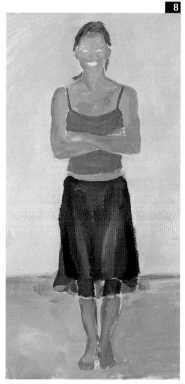

9 Now some definition is added to the shoulders, the chest, the arms, and all the surfaces of the body and clothing of the model.

10 Acrylic paints allow the mixing and superimposing of colors, but they cannot be combined with layers of base colors (because those layers dry out quickly). Therefore, the shading of the volume has to be defined as the painting progresses.

11 Notice how each of the areas of the skin is worked out, creating some areas that are modeled with tones similar to those used for the base.

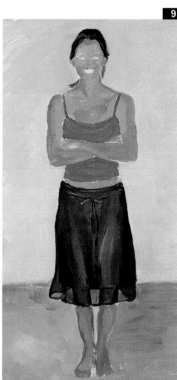

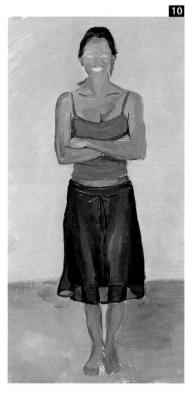

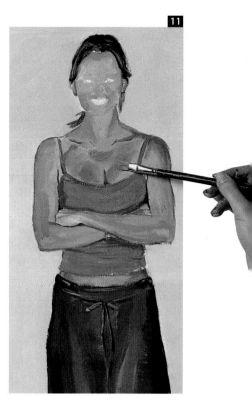

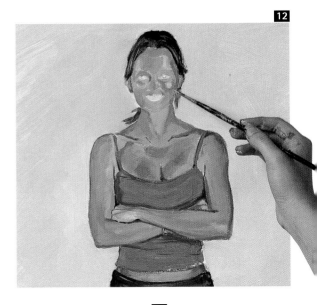

PAINTING THE SKIN WITH ACRYLICS
Because acrylic paints dry so quickly, the flesh tones have to be applied very differently from the way characteristic of oils. The common way is to spread a first layer of the correct tone and to work by areas, trying not to create visible changes in color. The advantage of acrylic paints is that they can be painted over soon after they have been applied.

12 When all the skin tones have been completed, the facial features are precisely defined to create the correct expression. Obviously, a thin brush has to be used, and special attention should be paid to the details.

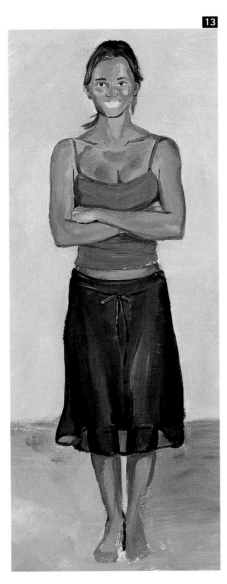

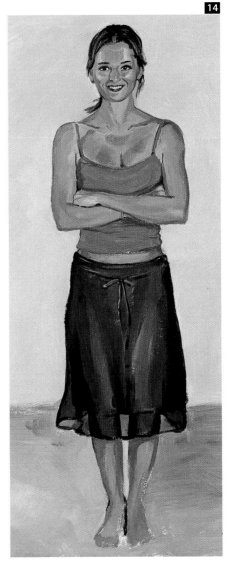

13 Little by little, the tones that give volume and coherence to the facial features are adjusted, leaving the resolution of the smiling mouth for the end.

14 The expression of the figure is becoming more natural, although the areas of the eyes and mouth still need to be defined.

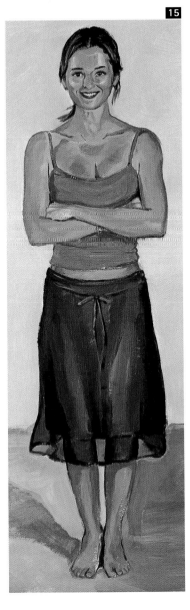

15 Finally, the naturalness of the expression of the eyes and the smile has been achieved thanks to some fine shading that reduced the excess of white paint.

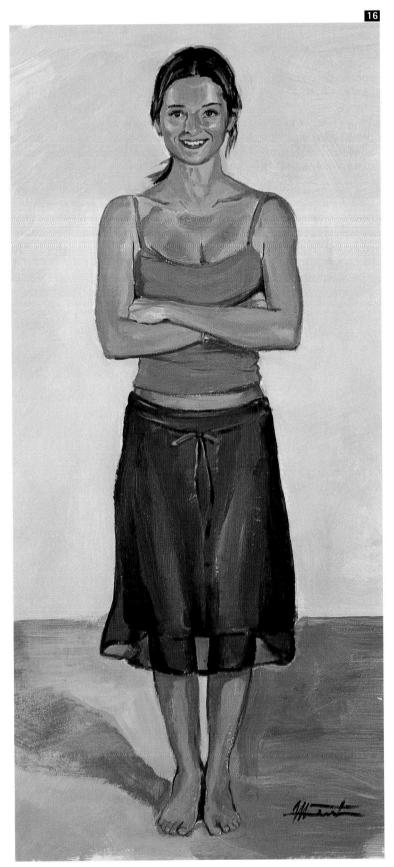

16 The final result is good proof that acrylic paints are as efficient and attractive in a portrait as any other type of paint.

Portrait in an Interior

This final exercise will present in these pages the process for painting a portrait in an interior setting. This type of work is halfway between a conventional portrait and a creative painting. Typically, there is not as much need for extreme accuracy in the likeness as is expected in other portraits, although the overall atmosphere should convey the flavor of the surroundings of the figure represented.

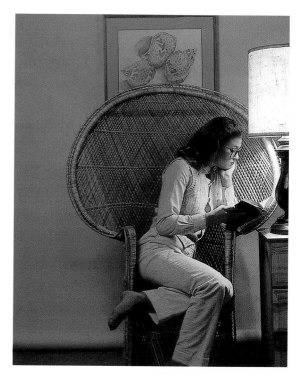

MATERIALS

- Watercolor paper of medium texture
- Watercolor paints: yellow ochre, burnt sienna, Payne's gray, emerald green, and cerulean blue
- One wide, round brush made of ox hair and one round brush made of sable hair

TECHNIQUES USED

- ◆ Composition for a full-length portrait ◆
- ◆ Blocking in the head ◆
- ◆ Shading ◆

Daily life offers many situations that can be converted to an artistic theme. A figure in its regular environment and devoted to any task is the essence of an intimate portrait.

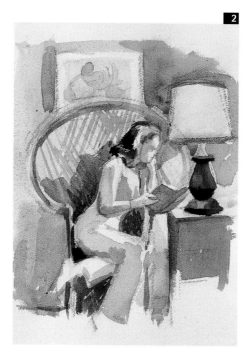

1 Before applying the watercolors, making some sketches of the composition and the color of the work is important. This picture illustrates the overall feeling of the areas of light and shadow done with lines that are almost monochromatic.

2 This is a much more elaborate study that establishes the contrasts of the composition and that begins to deal with the problem of the play of light on the figure.

3 The first step of the process is to do a pencil drawing of the composition. The point on the pencil should not be too soft in order to prevent the lines from remaining visible at the end of the project.

4 The completed preliminary drawing. Pointing out the level of the detail and the way the artist has drawn over the most significant outlines of the subject is important.

WATERCOLOR TECHNIQUE

The characteristic process of painting with watercolors consists of applying very diluted strokes of color, adding the most intense accents as the composition becomes more defined. Watercolors are transparent, and their luminosity depends on that transparency. Watercolors require a bold technique because any mistakes are hard to correct.

5 The first color is applied to the edges of the chair and the figure's hair. The pants and the lamp are colored with much lighter applications of watercolor.

6 The first applications of color already hint at the chromatic harmony that will dominate the composition: warm colors (light ochre and sienna) for the immediate surroundings of the figure and somewhat cooler tones for the rest.

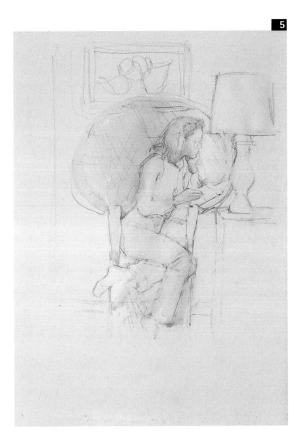

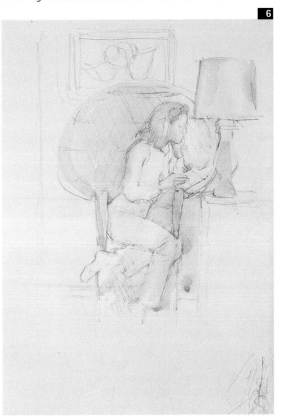

MIXING AND OVERPAINTING
Watercolors can be mixed either on the palette or on paper. The tone of a color that has already been applied can be modified while it is still wet by adding a brush stroke of another color. The effect will not be as homogenous as when the colors have been previously mixed. However, that is precisely the effect that some watercolorists are looking for and what gives the work interest and personality.

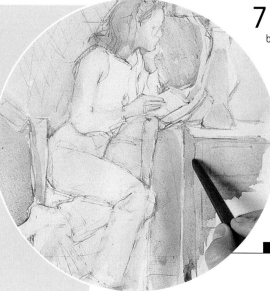

7 Very fine lines can be made on the wet paint by pressing with the handle of the brush into the damp paper. The color penetrates the indented line and creates a line of the same color as the surrounding area.

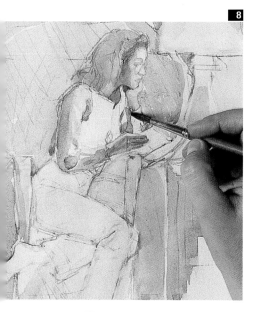

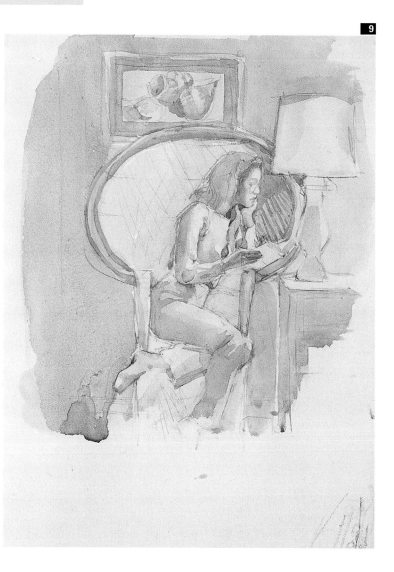

8 The areas of the head and the hand are the ones that require the most attention. Each one of the small areas of color must be applied with special care because they are the ones that construct the shape of the head and define the play of light and shadow.

9 The delicate coloring that the work gradually acquires increases in intensity progressively. Each time that a shadow is intensified, other tones must be adjusted to maintain the overall harmony.

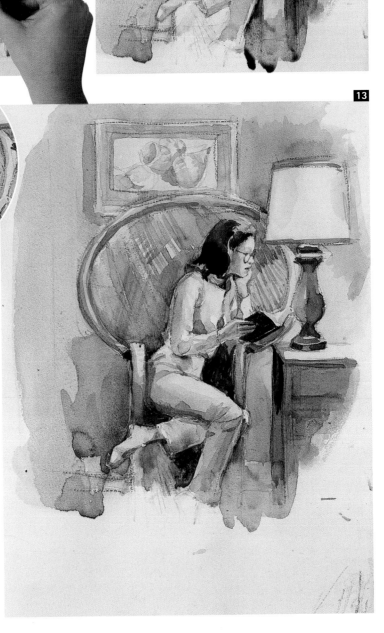

10 Pastel colors can be used to retrace or highlight an outline or a shadow as long as the lines do not ruin the general feeling of the work.

11 The overall darkening of the chair has emphasized the figure, whose contours and volume stand out against it.

12 By continuing with the work of intensifying the tonal values, the hair of the figure has now been darkened and the head stands out much more clearly.

13 The general feeling of the work has reached a point where a few small touches will leave the work completed.

THE LOOSENESS OF THE RESULTS

Watercolor paintings do not withstand excessive finishing. The colors are much more vibrant and interesting when they are played against each other with free strokes than when they are completely confined within the outlines of a drawing. Therefore, in its final state, a watercolor painting should maintain, to a degree, the freshness of an unfinished look.

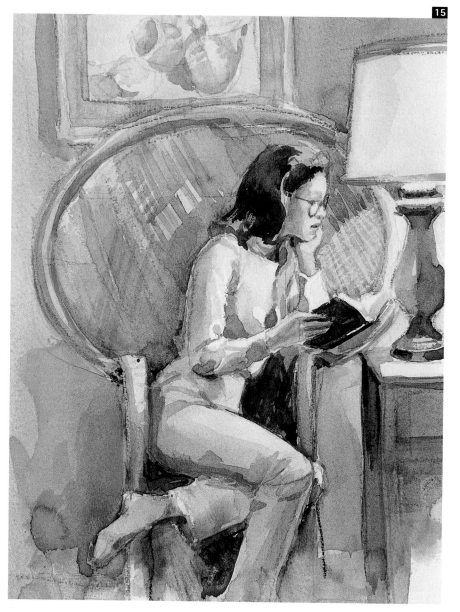

14 Pastel is applied to the upper part of the chair one last time to make it seem more separate from the wall in the background. The applications of pastel colors should always be minimal so as not to ruin the characteristic quality of the watercolor.

15 The work is completed when the artist has been able to represent the intimate atmosphere characteristic of this type of subject matter.

Related Barron's titles:

Art Handbook: Portraits
(ISBN 0-7641-5108-8) Barron's Educational Series, Inc.,
2002

Painter's Corner: Anatomy for the Artist
(ISBN 0-7641-5557-1) Barron's Educational Series, Inc.,
2002

Art Handbook: Anatomy
(ISBN 0-7641-5355-2) Barron's Educational Series, Inc.,
2002

The Basics of Artistic Drawing
(ISBN 0-8120-1929-6) Barron's Educational Series, Inc.,
1994

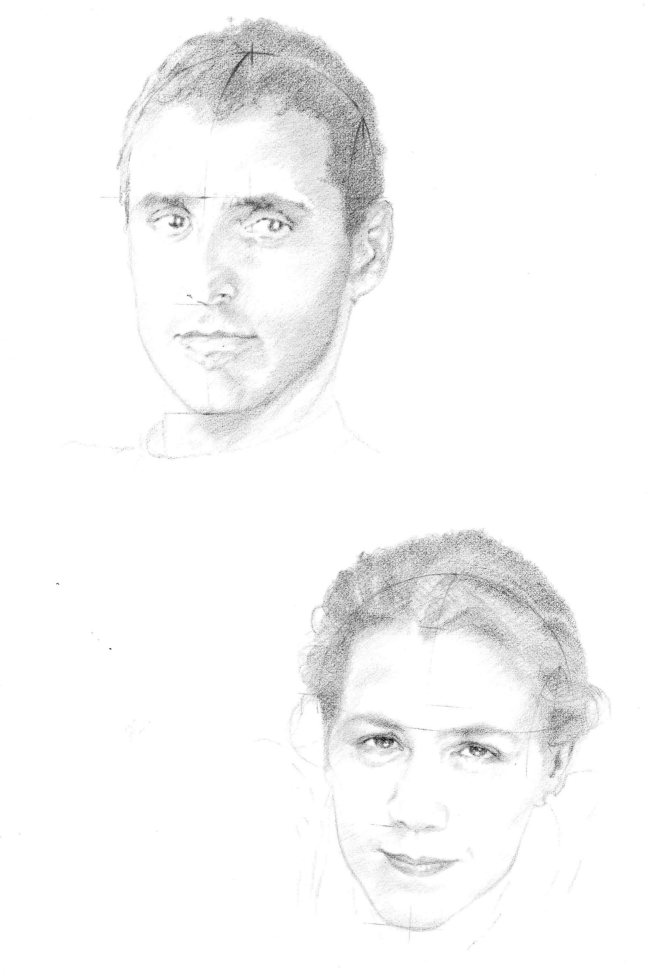